PARIS
LOST

Feliks Topolski

Introduced by Jonathan Stone

PARIS LOST

A Sketchbook of the Thirties

Hutchinson · London

Hutchinson & Company (Publishers) Limited
3 Fitzroy Square, London W1

London Melbourne Sydney Auckland Wellington Johannesburg
Cape Town and agencies throughout the world

First published November 1973
This edition has been printed in Great Britain by Lund Humphries,
12 Bedford Square, London, and The Country Press, Bradford

The book has been designed by Norman Ball, Chief Designer to the
Hutchinson Publishing Group Limited

The types used are:
For the body of the text: 16pt Bembo, produced by The Monotype
Corporation Limited, and photoset by Oliver Burridge and Company
Limited, Priestley Way, Crawley, Sussex
For the titling: University Roman

The paper is Clanblade Cartridge 140 g/m², manufactured by The
Inveresk Paper Company Limited, and supplied by William Guppy
& Company Limited, Cross Green Way, Pontefract Lane, Leeds

The drawings have been reproduced by four-colour offset process from
plates made by Lund Humphries, The Country Press, Bradford

The edition has been bound using Goodall's Crash Canvas supplied by
Winterbottom Products Limited, Victoria Mills, St Luke's Road, Weaste,
Salford. The cover boards are ·090 Millboard

The endpapers are Strathmore Grandee, Valencia Red, 120 g/m²,
supplied by G. F. Smith & Son Limited, Lockwood Street, Hull

The jacket material is Abbey Mills Glastonbury Antique Laid, Suede
107 g/m² supplied by Grosvenor Chater & Company Limited, 68
Cannon Street, London

ISBN 0 09 117620 4

for A.G.

Introduction

The story of the origins and subsequent adventures of Feliks Topolski's drawings of *Paris Lost* – for him doubly lost – lends an added poignancy to the pleasure given by their astonishing draughtsmanship. It is a story based on fact – their survival through the ravages of wartime travel between Poland, Spain and Germany, their appearances and disappearances – but there are gaps in it and unexplained mysteries, so that parts are necessarily the subject of some conjecture and hypothesis.

Already in the early nineteen thirties, Topolski, as a young artist in his twenties, was making a considerable name for himself in his native Poland. 1933 was the year of his first 'grand tour' of Europe when he visited Austria, Italy, Germany, France and England; he spent a long period in Paris – and a much shorter one in London. By then the first reproductions of his work had been published in Warsaw; and he had completed some important murals at the IPS (Institute for the Propagation of Modern Art). On his second visit to London, Topolski's first book in England, *The London Spectacle 1935*, was published by John Lane, The Bodley Head.

The publication of the book and his successful exhibition at the Wertheim Gallery did much to persuade Topolski to settle in London. In 1936 Topolski became a regular feature contributor to *Night and Day* and it was whilst he was working on the magazine with Graham Greene, Evelyn Waugh and other members of the lively group connected with it, that he met John Marks, a Cambridge man and an hispanophile of Swiss origins who was with the British Embassy in Madrid during the war and who returns to the scene later in the story.

Paris was still the cultural and intellectual centre of Europe and Topolski, a frequent visitor in the years leading up to the war, found a wealth of easily accessible material for his racy line, sympathetic at times; at others, coruscating and caustic. As it still does today. Paris maintained its unrivalled tradition as the home of *cabaret*; and the animated atmosphere of the *boîte* of Suzy Solidor, for example, attracted Topolski no less than it did Jean Cocteau,

Van Dongen, Raoul Dufy, Kisling, Marie Laurencin and Picabia. But other material was denied him until he met a Spanish Academician of great distinction, Eugenio d'Ors – professor, novelist, 'foremost among contemporary art critics', according to Léon Daudet, philosopher and diplomat – who was Permanent Secretary of the Spanish Institute. Señor d'Ors, a Catalan by birth, but a natural cosmopolitan who had aptly described himself as 'the Wandering Catholic', was living in Paris at the time. He enormously admired Topolski's work and proposed collaboration between them on a book – a medley of Parisian drawings and words. D'Ors was well-known to all the contemporary *personnes de qualité* – as Molière called them – in Paris. He introduced the young Topolski to the social, artistic, musical, diplomatic, and literary worlds of La Duchesse de la Rochefoucauld, Maurois and Mauriac, the Mozart Club (*La Société d'Etudes Mozartiennes*), Elsa Schaiparelli – 'Schiap' – in the Rue de la Paix, the High Court of *Haute Couture*, and the lectures of Paul Valéry. And d'Ors talked of Picasso and how during 'the period when he was holding the sceptre of avant garde art he would never agree to exhibit a picture of his without a sumptuous frame, not an old one, mark you, but one rich and heavily gilded – as Louis XV as possible!'; and, then, of Wildenstein, the antique dealer, who solicited d'Ors' admiration 'for some old thing of the 18th century' to which he replied, 'What I like best about it is the design of the frame. . . .'

D'Ors warned Topolski that etiquette demanded an appearance or, rather, something stronger – *une acte de présence* – at four tea-parties at least, of which one would be a cocktail party – the minimum requirement for any self-respecting member of Paris society of the day. The prattle was not untypical. '. . . My dear Princess, I am happy to introduce to you my friend, Feliks Topolski, the great draughtsman of the London scene. You will ask him whether he is now living in Paris and what he thinks of *Il Duce's* foreign policy. . . .'

As d'Ors guided Topolski around Paris he praised its unchanging characteristics and characters, 'the bookworm, the Bohemian, the elderly rake, the tart, the pick-pocket, the abbé, the student, the leading lady, the tramp, and the little woman', all portrayed by Topolski.

Altogether, by the end of 1938, Topolski had completed a remarkable collection of just over two hundred drawings of Paris and d'Ors wrote four dialogues of imaginary discussions between himself and the Artist to accompany them. Arrangements were made for the publication of what was

originally entitled 'Paris Scenes and Secrets – Recorded and Revealed by the pen of Eugenio d'Ors and by the pencil of Feliks Topolski' by the Minerva Publishing Company whose driving force was Ignacy Lindenfeld, a Polish publisher who was working for Przeworski's Publishing House, a leading firm in pre-war Warsaw. The drawings, of which satisfactory proof pulls had been provided by the printers in Cracow, were to be reproduced in two-colour offset. The text was translated from d'Ors' original French by John Marks of *Night and Day* fame who had been introduced to Lindenfeld by Topolski and who became Minerva's English literary adviser. It was set by Lund Humphries, the printers of the whole of this edition of ninety-six drawings, in 18 point Baskerville type, and progress was such that a prospectus was prepared by the proposed publishers, promoting the trade edition of the book to be sold at £1.10.0d. (pre-publication price £1.1.0d.), and a limited edition of twenty-five copies, signed by Señor d'Ors and Mr Topolski, offered at five guineas. Publication in England was fixed for 15th September 1939, and further editions were planned for Paris and Warsaw. None of the editions ever appeared, and the outbreak of war saw all the original drawings in Poland.

On the fall of France in 1940, Eugenio d'Ors returned to Madrid. From his office as *El Secretario Perpetuo* of the *Instituto de España* at *El Palacio del Sacramento*, he made contact with the German Embassy in Madrid in the hope that through wartime diplomatic channels he would be able to use his influence to have the original drawings prised out of Poland and sent to him in Madrid; and, indeed, his standing was such that he was initially successful in his efforts. Two members of the Gestapo in Warsaw presented themselves at the offices of Przeworski to the utter terror of the proprietors for whom a visit from the Gestapo spelled – as they thought – certain arrest, and probable death; the story of the visit was recounted to Topolski after the war by Dr Przeworski, the brother of Marek, the head of the publishing firm who had died in the Ghetto uprising. Their requirements were, however, less demanding – quite simply the portfolio of Topolski drawings.

It is not entirely clear from the correspondence passing between d'Ors and Topolski when exactly the drawings arrived in Madrid, since in d'Ors' first surviving letter of 19th May 1941, he tells Topolski that in letters which he had written to him in the previous autumn (and which never arrived at their destination) he had told him how the drawings had been finally retrieved; and yet in a later letter of 6th February 1942, he tells Topolski

that the drawings had been in Madrid since 'last summer', but that he had not been informed on account of the illness and absence of the person to whom they had been entrusted. Could it be that the drawings rested in Berlin on their way from Warsaw to Madrid and that the missing letters did not refer to their arrival in *Madrid*? According to d'Ors, 'they' (presumably the Germans) were prepared to release the drawings to him on condition that he presented himself as proprietor and at the same time – according to his last information (10th May 1941) – that he deposited with 'them' a sum equivalent to the value of the drawings according to the publishing contract. All the while d'Ors was working with José Janés, a publisher from Barcelona, with a view to producing a Spanish edition of the book. There were, however, certain problems to be overcome. Janés left for Barcelona, having asked d'Ors to give him a week or two to work things out; and, in turn, d'Ors asked Topolski to leave to him the handling of the affair, on the understanding that 'as soon as the present circumstance ceased' he would pass the drawings back to him. All the correspondence which appears to have survived was exchanged through Professor Walter Starkie at the British Institute in Madrid.

Eventually after several months of discussions between d'Ors and the German Embassy, d'Ors was told that the drawings would no longer be available since their withdrawal to Berlin had been ordered by a higher authority: his ceaseless representations availed nothing.

What is totally unclear is whether the order to the German Embassy in Madrid came from the *Reichskanzlei* in Berlin – in other words from Hitler – or from Goebbels the Reich Minister of Propaganda and what the purpose of the order was. There are two conjectures: first, that Hitler had heard that the drawings were of architectural or artistic interest and sought them in his 'artistic' capacity – since he regarded the Paris *Opéra* as the height of architecture. Perhaps he had even seen the drawings on their journey from Warsaw to Madrid. The second possibility is that Goebbels required the drawings for wartime propaganda purposes. Certainly the suggestion that the drawings might have propaganda value makes eminently good sense. Topolski was an Official British War Artist and at least one of his *Blitz* drawings, namely that of a tired ARP Warden, which was originally reproduced in *Illustrated London News,* and subsequently as one of the Penguin 'Topolski Prints', was used by the Nazis (without payment of royalties!) in some of their propaganda to demonstrate the plight of wartime Britain.

PARIS
SCENES AND SECRETS

RECORDED AND REVEALED
BY THE PEN OF
EUGENIO D'ORS
AND BY
THE PENCIL OF
FELIKS TOPOLSKI

FOUR DIALOGUES
AND
TWO HUNDRED DRAWINGS

MINERVA PUBLISHING CO. LTD
36 GREAT RUSSELL STREET, LONDON, W.C.1

EUGENIO d'ORS, of the Spanish Academy, is a prophet not without honour—and honours—in his own country; but to this distinction he has added the achievement of fame in most European countries. If to the English public his name is still largely unfamiliar, that omission may no doubt be ascribed to the fact that ours is a language which this talented linguist reads but does not write. Professor, lecturer, novelist, art-critic, philosopher and diplomat, Señor d'Ors is a Catalan by birth, but by nature a cosmopolitan who has aptly described himself as—"the Wandering Catholic". His published works include *Trois Heures au Musée du Prado*, *Cézanne, Picasso, Jardin des Plantes, Au Grand Saint Christophe, L'Art de Goya, La Vie de Goya, Coupole et Monarchie, Du Baroque, Ferdinand et Isabelle: Rois Catholiques d'Espagne*, a new laconic tour-de-force, *l'Histoire du Monde en 500 Mots*, and a remarkable novel, *La Bien Plantada*. Yet overtopping this prolific list is his massive *Glossary*, now in the course of preparation: thirty volumes of a "diary of the mind" which Señor d'Ors has jotted down, from 1906 to 1937, on the fleeting leaves of the daily Press. This omnibus substantiates the author's preference for being regarded as neither primarily a philosopher ("the Socrates of modern Spain", Herr Vogel has called him) nor yet simply as an exponent of æsthetics ("foremost among contemporary art-critics", to quote Léon Daudet), but rather as "a specialist in general ideas". It is in this capacity—with special reference to the world of Paris—that we have the pleasure of presenting the Permanent Secretary of the Spanish Institute and Director-General of Bellas Artes to English readers.

FELIKS TOPOLSKI stands in no need of formal introduction to those who were the victims of his satirical pen in that pertly perfect vision of England, *The London Spectacle 1935*—willing victims, too, if we are to judge by the chorus of unanimous praise with which his talent for caustic yet charming portraiture was hailed by the reviewers. Since that moment of first impact when he held a highly successful exhibition here, Mr. Topolski has devoted himself to accurate and decorative comment on the (so he says) exotic character of English life and the peculiar civilisation of France. In Mr. Agate's words he has "re-established belief in something which the comic and illustrated Press of this country had led one to believe to be extinct—the art of comic drawing. His sketches are every bit as good as Gavarni, and they are as amusing as Peter Arno." They have been described, by the *Scotsman*, as "superlatively clever and nimble drawings, so shrewd, so strong, so illuminating" that if you "take a hint of Guys and a flavour of Daumier and a dash of Grosz, add much that is possibly Polish and certainly new, stir the mixture

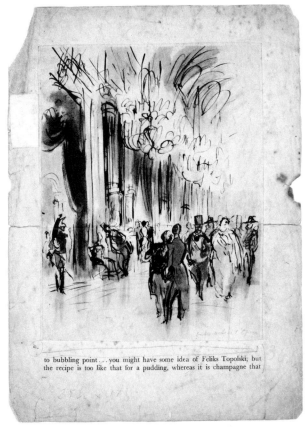

to bubbling point . . . you might have some idea of Feliks Topolski; but the recipe is too like that for a pudding, whereas it is champagne that

should be suggested, though champagne is not strong enough." *Vogue*, on the other hand, decided that "the artist's line reminds one both of Hogarth and Daumier, but remains individual", whereas the great G.B.S. himself—the book of whose play, *Geneva*, Topolski recently illustrated—has described him as "an astonishing draughtsman, perhaps the greatest of all the Impressionists in black and white". His delightful drawings in the *News Chronicle* are well-known. As they vividly depict the London scene, so here he gives us the whole of Paris in the twinkling of an eye.

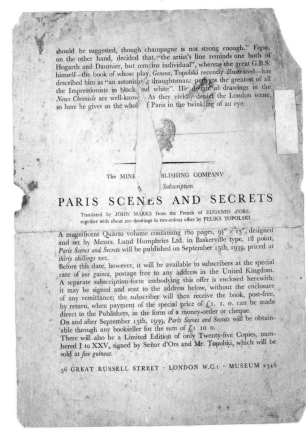

The MINERVA PUBLISHING COMPANY
on Subscription

PARIS SCENES AND SECRETS

Translated by JOHN MARKS from the French of EUGENIO d'ORS,
together with about 200 drawings in two-colour offset by FELIKS TOPOLSKI

A magnificent Quarto volume containing 160 pages, 9¼" × 13", designed and set by Messrs. Lund Humphries Ltd. in Baskerville type, 18 point, *Paris Scenes and Secrets* will be published on September 15th, 1939, priced at *thirty shillings* net.

Before this date, however, it will be available to subscribers at the special rate of *one guinea*, postage free to any address in the United Kingdom. A separate subscription-form embodying this offer is enclosed herewith; it may be signed and sent to the address below, without the enclosure of any remittance; the subscriber will then receive the book, post-free, by return, when payment of the special price of £1. 1. 0. can be made direct to the Publishers, in the form of a money-order or cheque.

On and after September 15th, 1939, *Paris Scenes and Secrets* will be obtainable through any bookseller for the sum of £1 10 0.

There will also be a Limited Edition of only Twenty-five Copies, numbered I to XXV, signed by Señor d'Ors and Mr. Topolski, which will be sold at *five guineas*.

36 GREAT RUSSELL STREET · LONDON W.C.1 · MUSEUM 2346

Reproduction of the only known remaining original prospectus.

Unfortunately, our best potential sources of information have run dry: none of the German ambassadors to Madrid during the War (Dr Eberhard von Stohrer, Hans Adolf von Moltke, and Dr Hans Heinrich Dieckhoff) is still alive; both José Janés and John Marks died about six years ago; and Eugenio d'Ors died in 1954.

When d'Ors and Topolski met again in 1951 for the first time since the war, d'Ors was unable to shed any light on the fate of the drawings and they both resigned themselves to the inevitability of their destruction and the non-appearance of their book. So convinced was Topolski that the drawings had gone for ever that he even allowed himself in 1954 to be persuaded by an eccentric continental jurist that there was a case to be presented to the Foreign Claims Commission for compensation for the lost drawings; but he hardly pursued the matter. What Topolski never knew when he was tramping the ruins of Berlin in 1945 as an Official War Artist was that the drawings were soon to be – or were already – safely in the hands of one Dr Hans Cürlis, the Director of the Kulturfilm-Institut GmbH in Berlin, who is now in his eighty-fifth year and who has, in the last fifty years, filmed over seventy painters and sculptors at work, starting with Louis Corinth. On 15th May 1963, Dr Cürlis wrote to Topolski for the first time (the letter which is reproduced as a frontispiece to this edition) to say that he had bought a parcel of drawings shortly after the end of the war from a Russian soldier near Kochstrasse, which is now in East Berlin, and that they were all in very good condition. It is for conjecture why four of the originals of which we possess proof pulls only have never been recovered; perhaps they were at the printers in Cracow, whereas the originals were with Przeworski in Warsaw. The soldier had been extremely selective and out of all the property available for looting he had, with a connoisseur's eye, picked the Topolski drawings out of the ruins of Berlin. Dr Cürlis 'found the pictures extraordinarily beautiful' and, for obvious reasons, had directed his enquiries about the drawings in a French direction. In view of the markings on the back of the drawings for the layout of the frustrated pre-war publication, Dr Cürlis asked M. Frechet, the Director of the French Institute in Berlin, whether a book of them had already been published. He also consulted the French Embassy but neither was able to assist on either the book or the artist. Finally Dr Cürlis approached the Keeper of the Department of Engravings – *das Kupferstichkabinett* – of the Berlin Museum where an assistant, Mr Anzelewsky, was able to decipher

Topolski's signature and to tell him that the artist was British and living in England. Mr Turner of the Information Services Branch, British Military Government, Berlin, told Dr Cürlis about Topolski's work and gave him his address. It was, however, not until November 1963 that Topolski received Dr Cürlis's letter of 15th May following the Artist's extensive, uninterrupted world travels. In February 1965, thanks to the warm co-operation of Dr Cürlis, the drawings were returned to Topolski who had not seen them for a quarter of a century or more.

For him their return was a miraculous event, but Feliks Topolski is a man of current appetites and engagements: the sixties were the high days of his *Chronicle*, recording the visit of the Pope to Jordan and Israel, for example – major commissions such as the portrait of Prince Philip for Windsor Castle, and a deep involvement in three important books, *Holy China*, *The United Nations: Sacred Drama* (with Conor Cruise O'Brien), and *Shem, Ham & Japheth Inc*. He thus made no more than desultory efforts to resurrect his Paris drawings to their proper place. Over twelve years have passed since Feliks Topolski and I worked together on *Topolski's Legal London*. We talked now and then over the years about our next point of collaboration, but it was only when I spotted a strange-looking dusty portfolio in his studio last Autumn and asked him what was in it, that he said, with casual modesty, 'Oh, just some drawings of Paris that I did before the war. . . .'

24th August, 1973 JONATHAN STONE

ACKNOWLEDGEMENTS

I am most grateful to the following for their assistance:–
Señorita M. C. Alvargonzalez, *Madrid*
Mrs M.-F. Cosgrove, *London*
Dr Hans Cürlis, *Berlin*
Professor Victor D'Ors, *Madrid*
Professor Alvaro D'Ors, *Pamplona*
Dr Juan Pablo D'Ors, *Madrid*
Mrs M. P. G. Draper, *Archivist, Bedford Settled Estates, London*
Professor H. R. Trevor-Roper, *Oxford*
Miss Celina Wieniewska, *London* J.M.L.S.

List of Drawings

The spelling used for the captions and in this list follows the artist's titling.

The Drawings

1. La Patronne

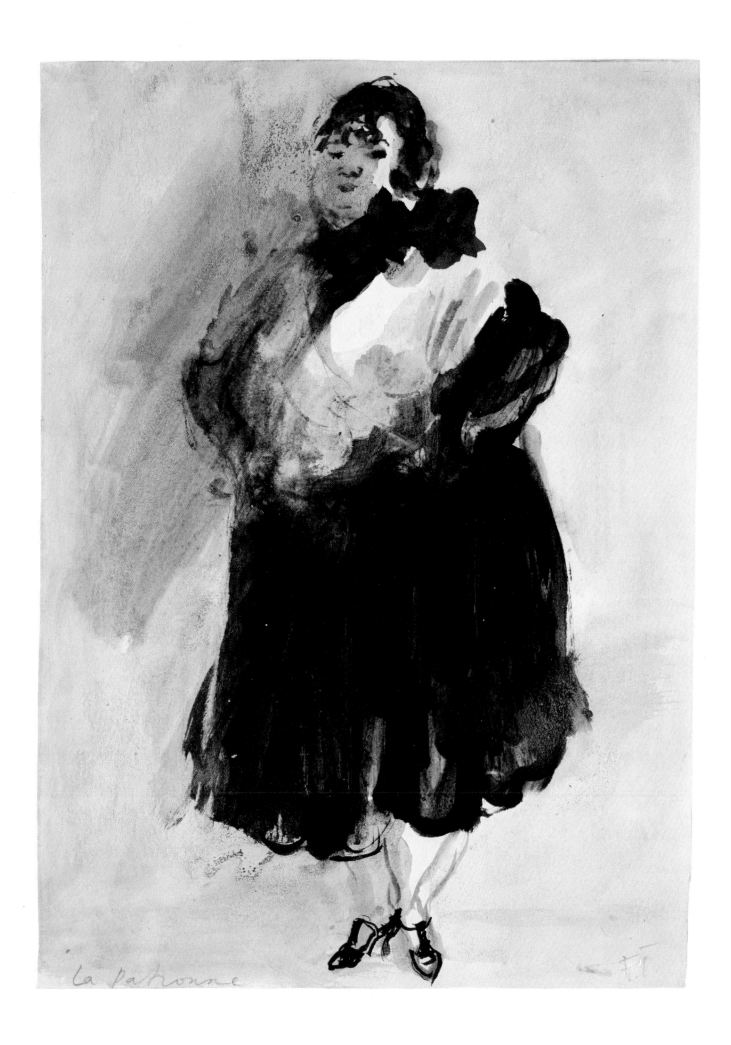

La Patronne

2. Café des Deux Magots

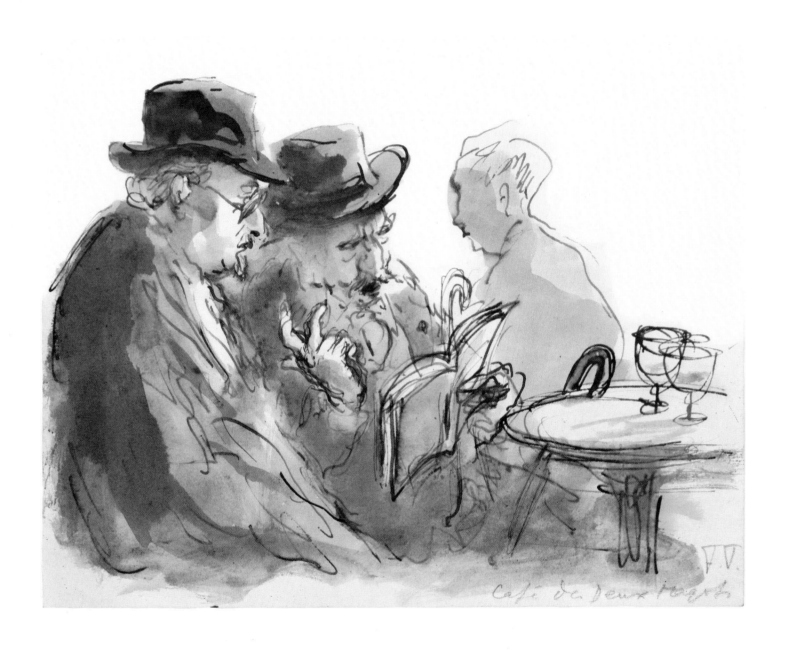

café de deux magots

3. Le Patron

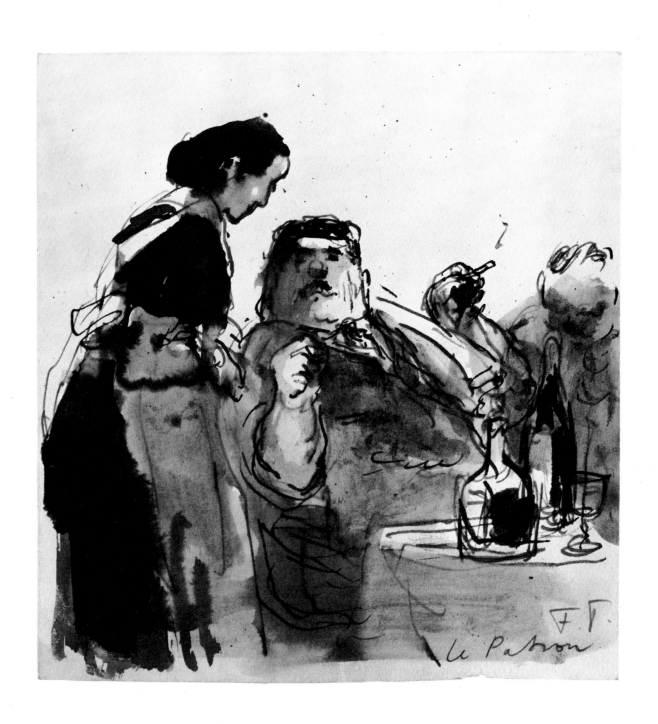

Le Patron

4. *Prunier*

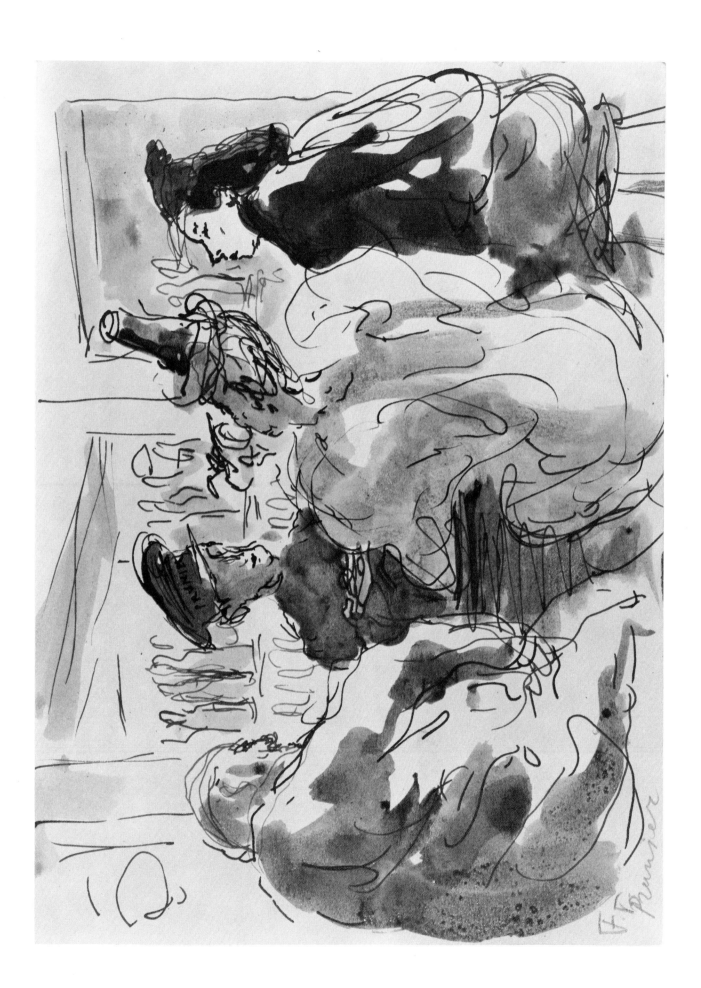

5. Arr. VI

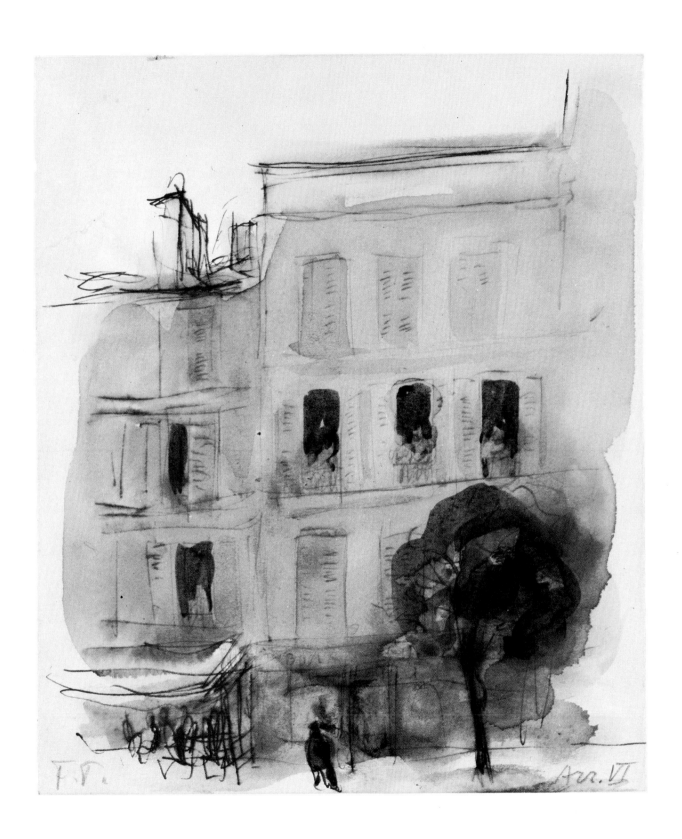

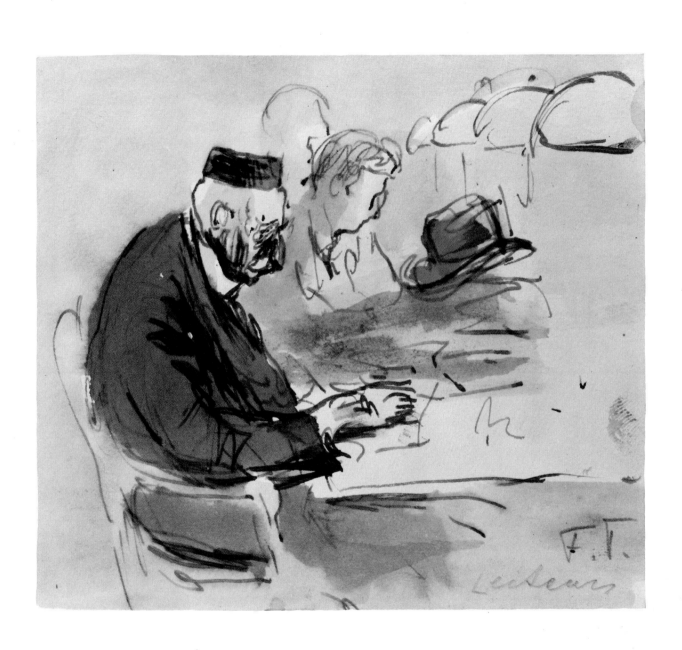

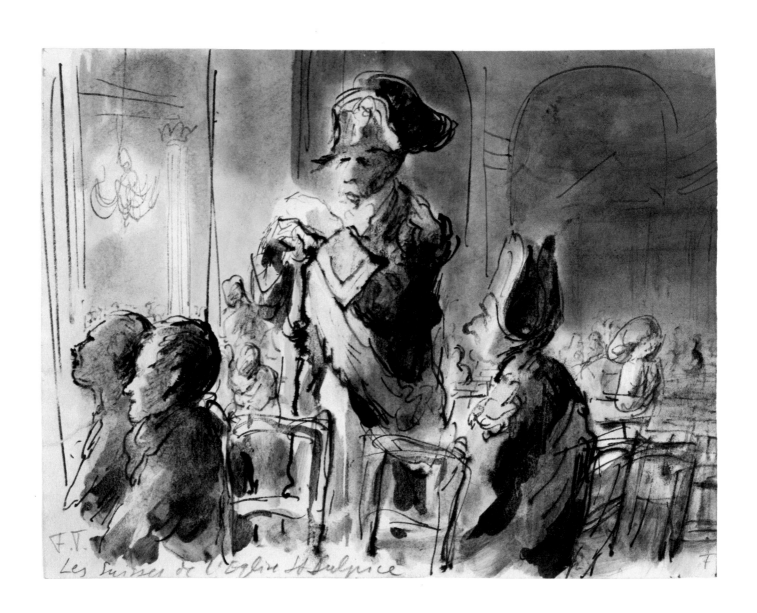

Les Suisses de l'Église St Sulpice

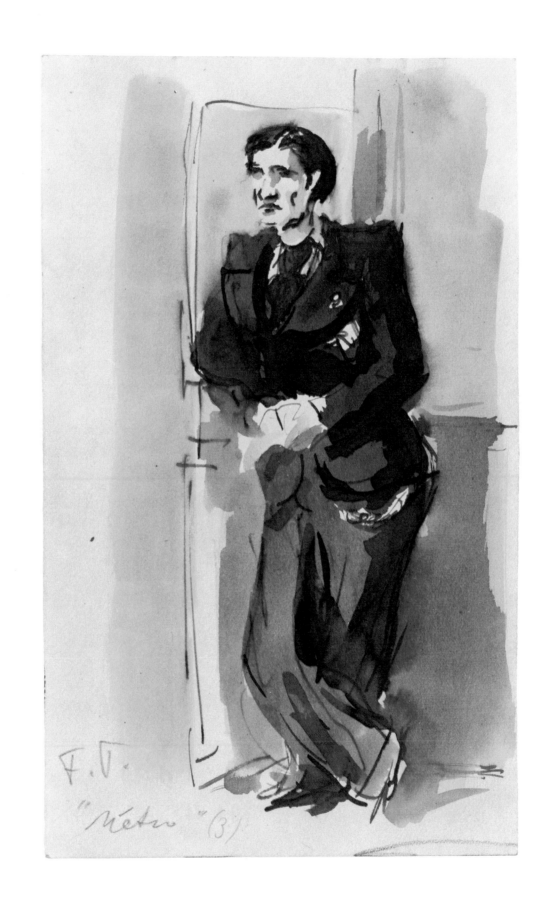

F. T.
"Métro" (3)

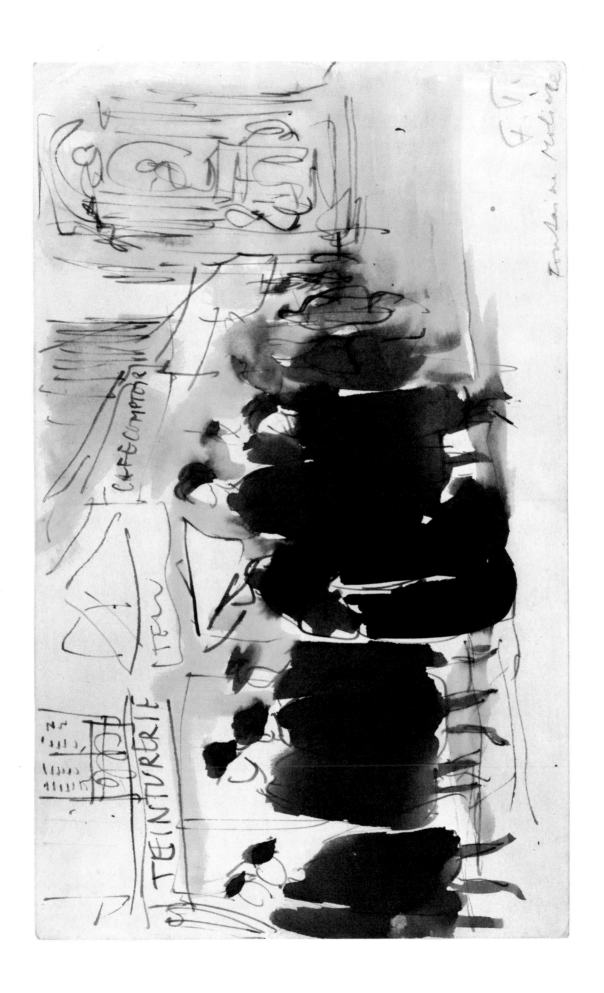

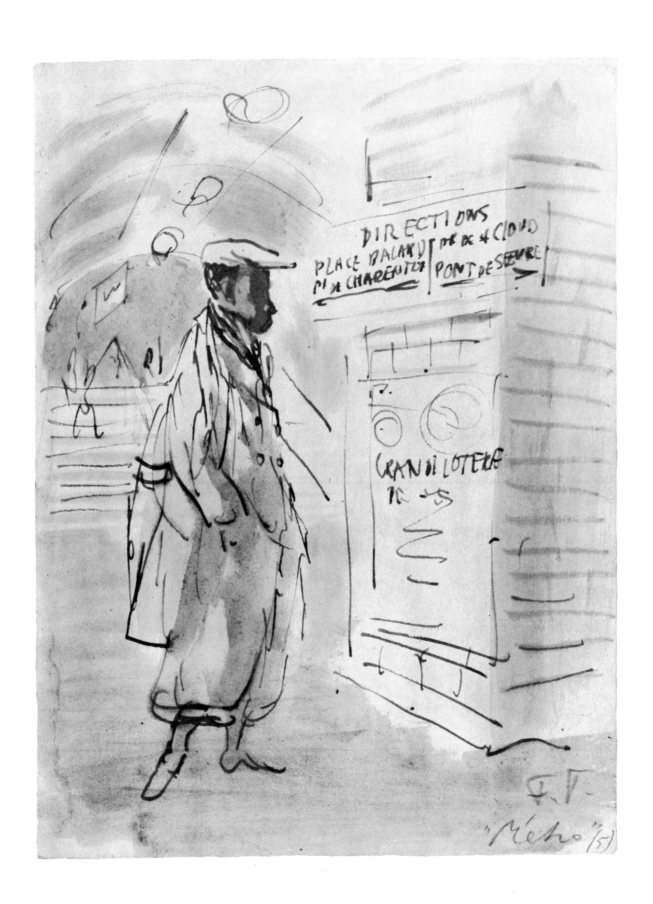

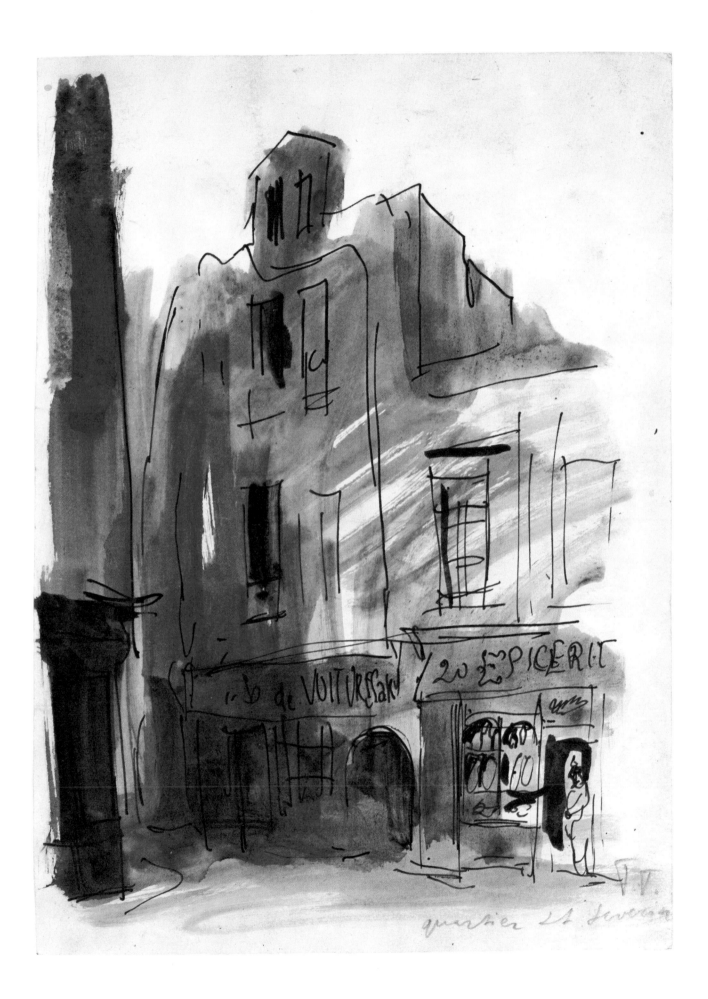

b de VOITURES 20 EPICERIE

quartier St Severin

12. *Le promenoir à l'A–B–C*

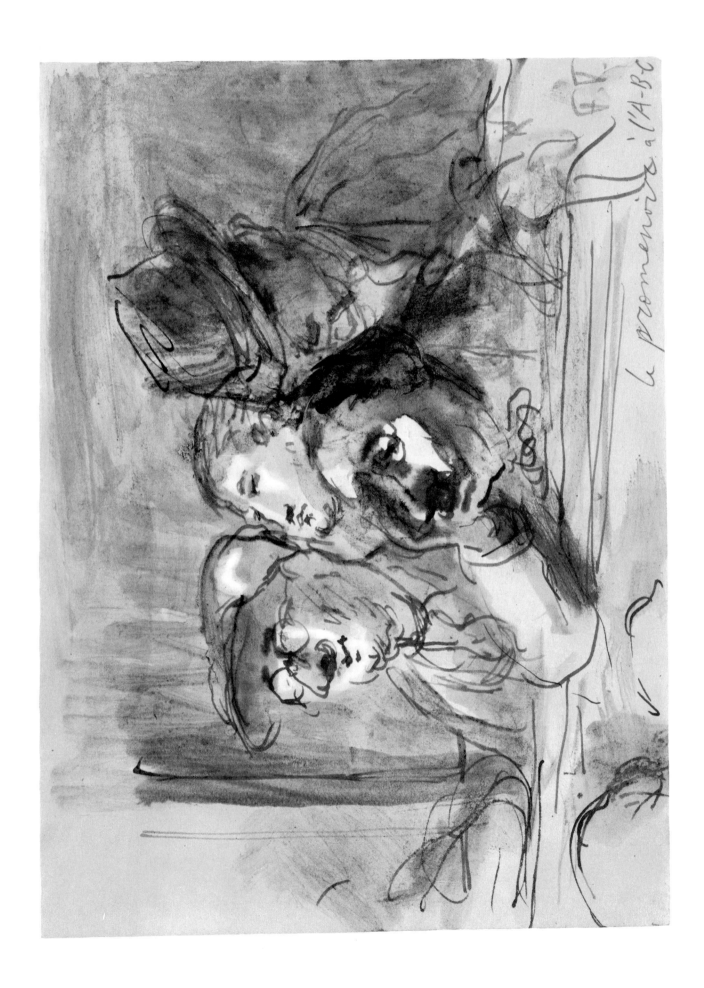

La promenade à l'A-BC

13. *A l' Ambassade*

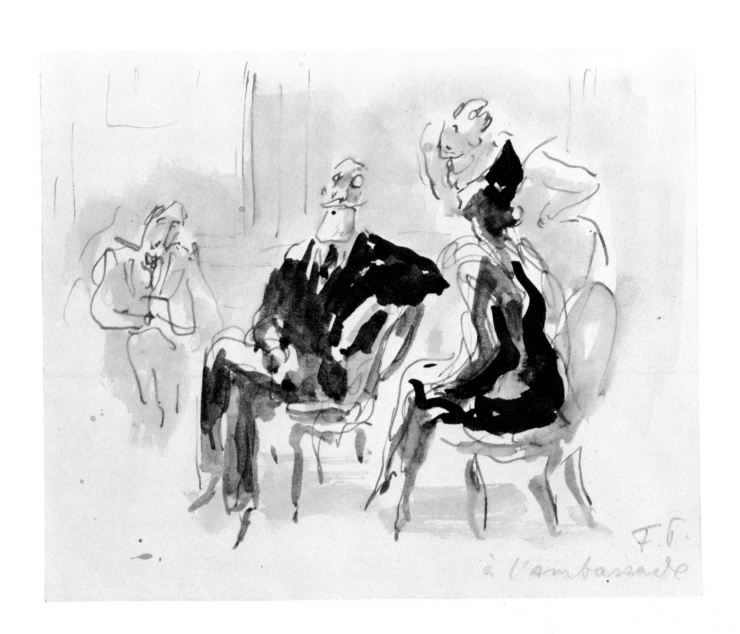

à l'ambassade

14. Place Bastille

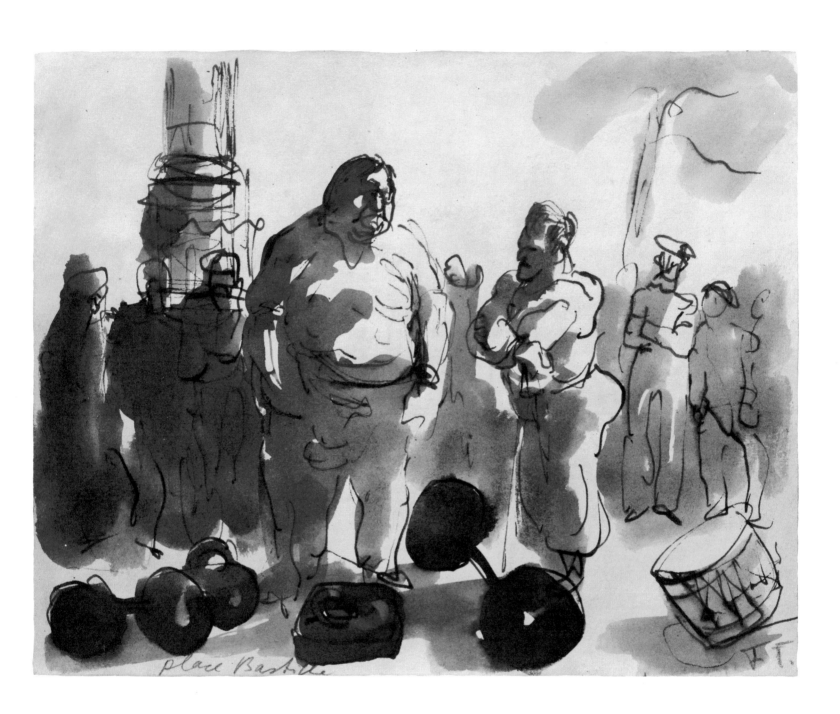

Place Bastille

15. *Chez Fouquets*

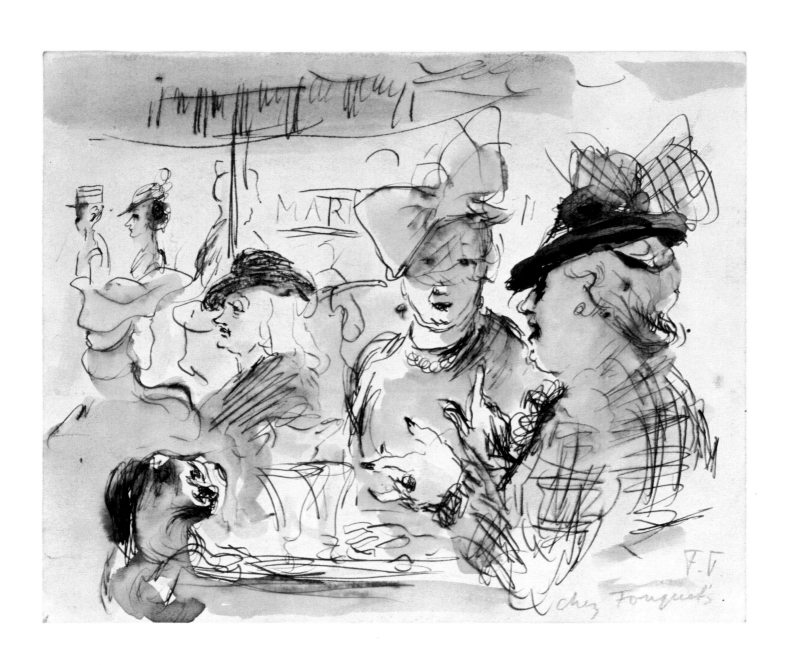

chez Fouquet's.

16. 'L'entre-acte à l'Opéra'

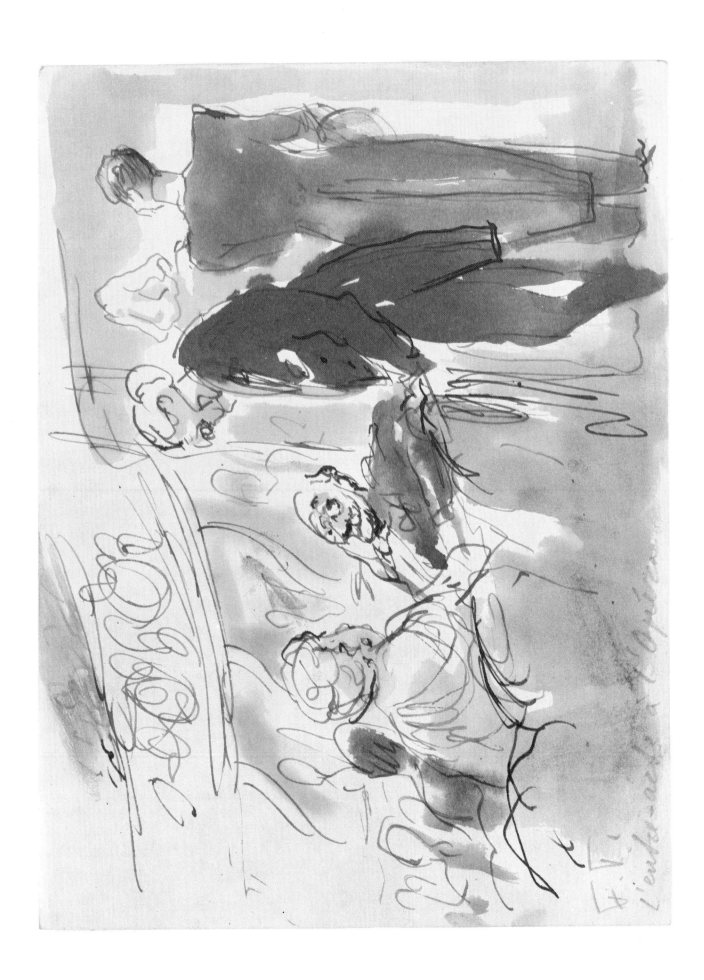

17. Boul. Blanche I

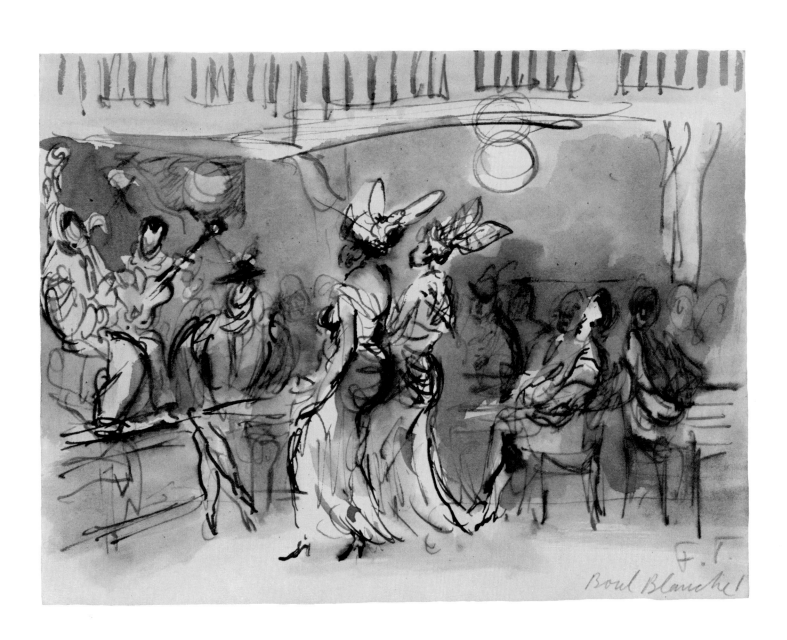

Boul Blanche!

18. *La Foire – Place de la République*

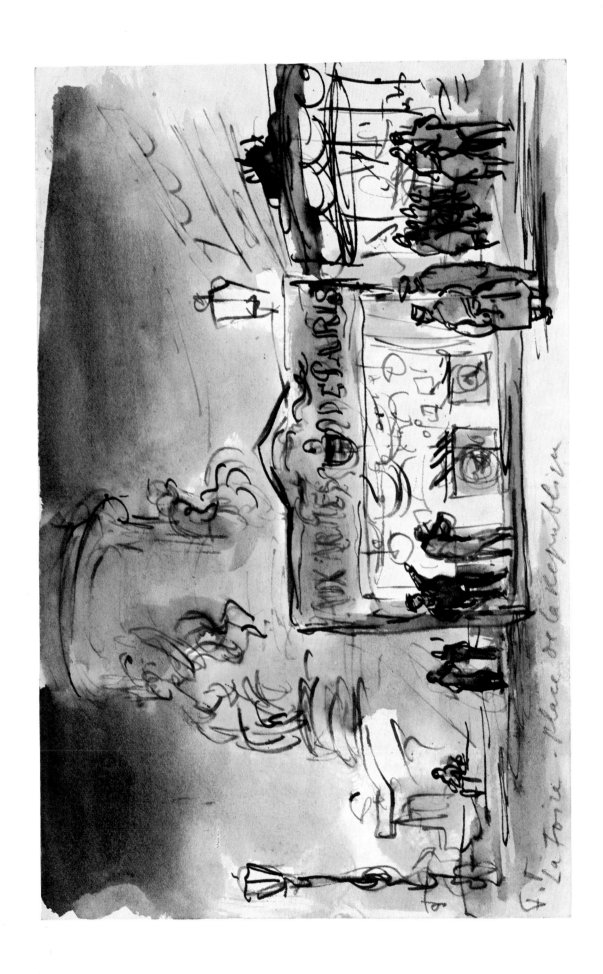

19. *Chez Suzy Solidor*

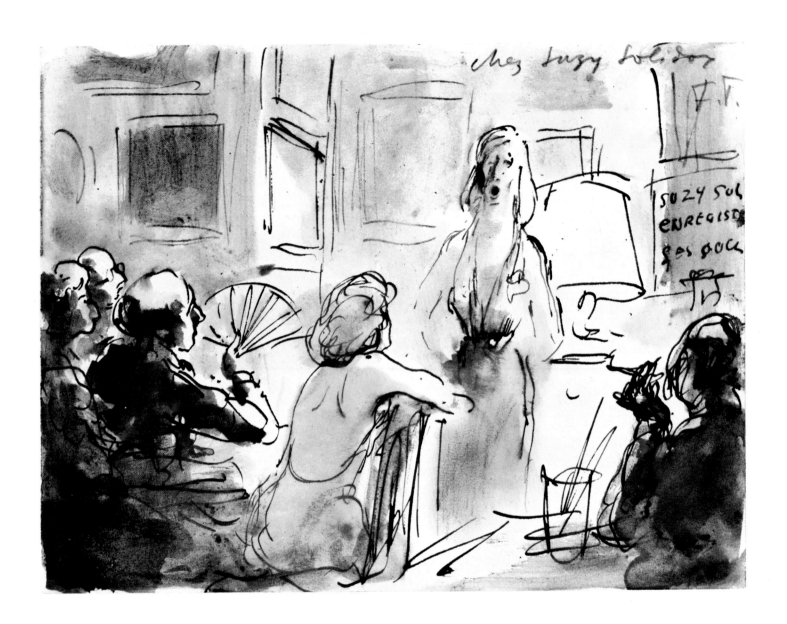

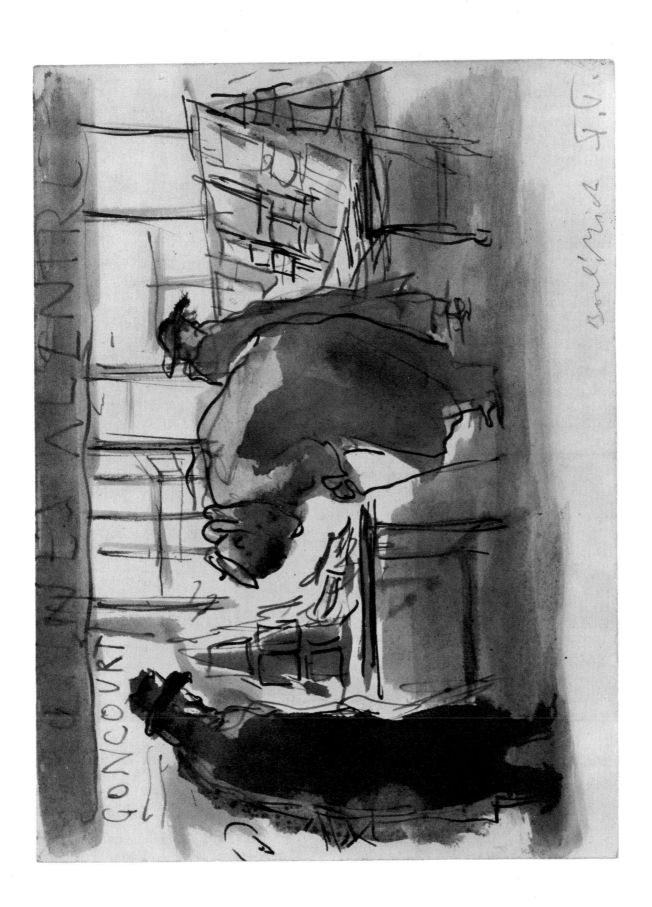

21. *La famille du patron*

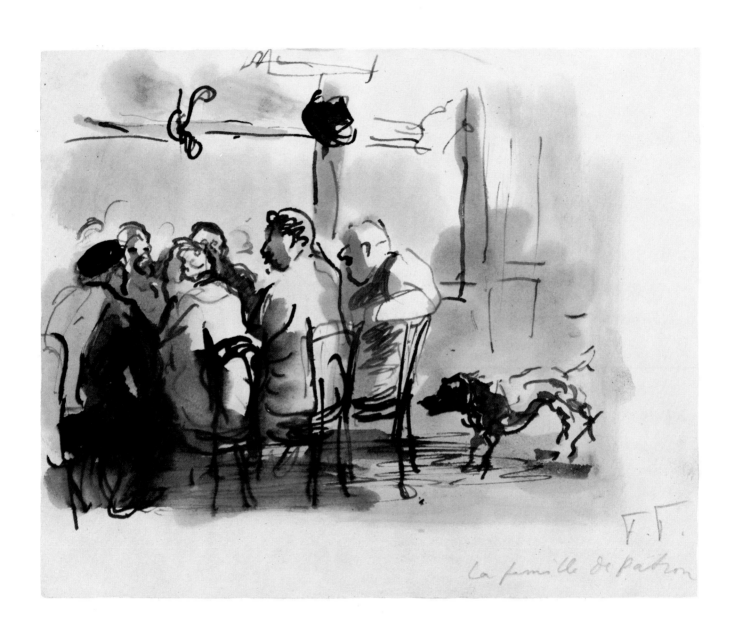

La famille de patron

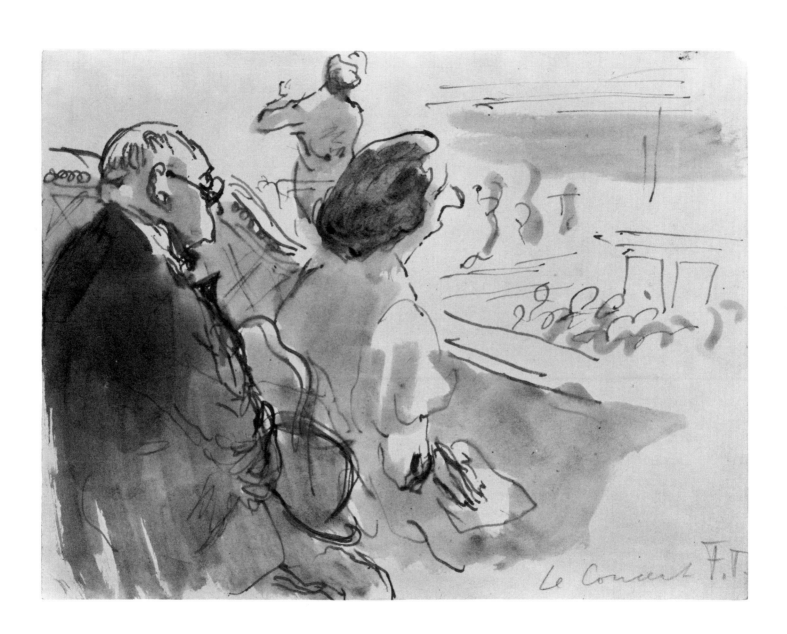

Le Concert T. T.

23. *St. Germain l'Auxerrois*

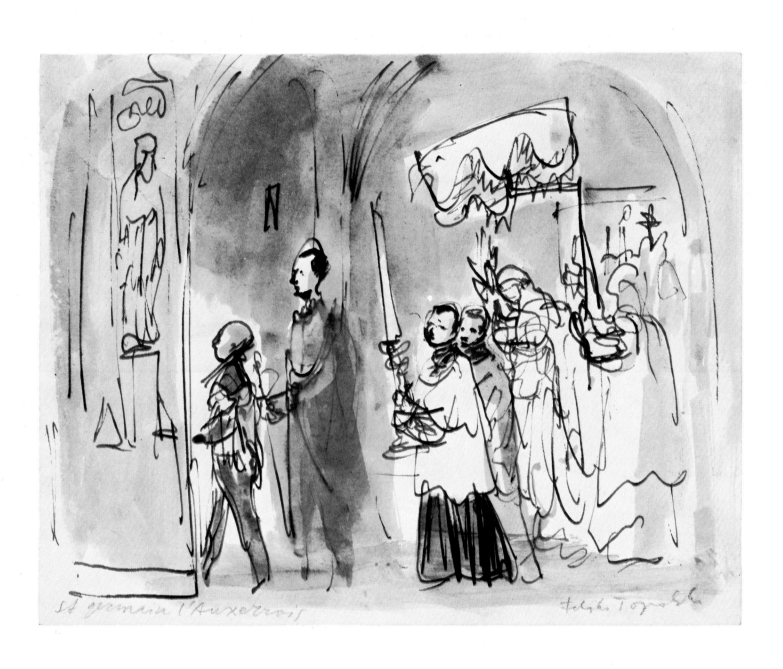

St germain l'Auxerrois Feliks Topolski

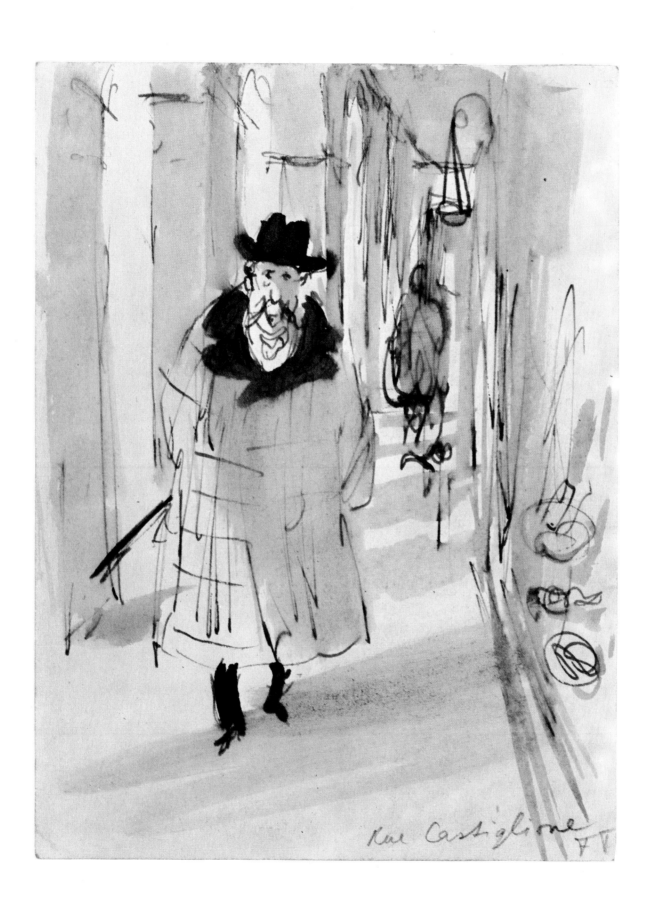

Rue Castiglione

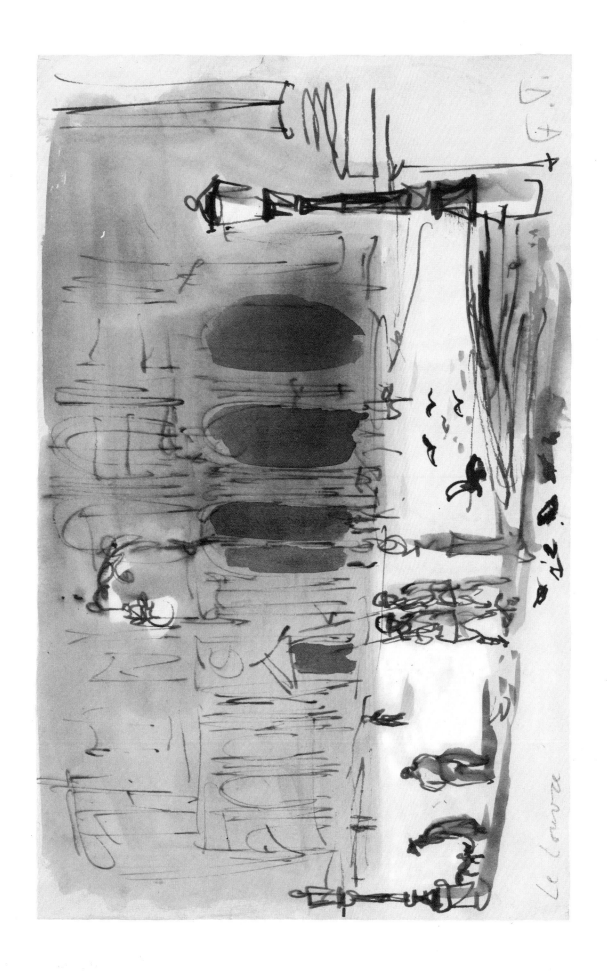

Le Louvre

26. *"Madeleine – Bastille"*

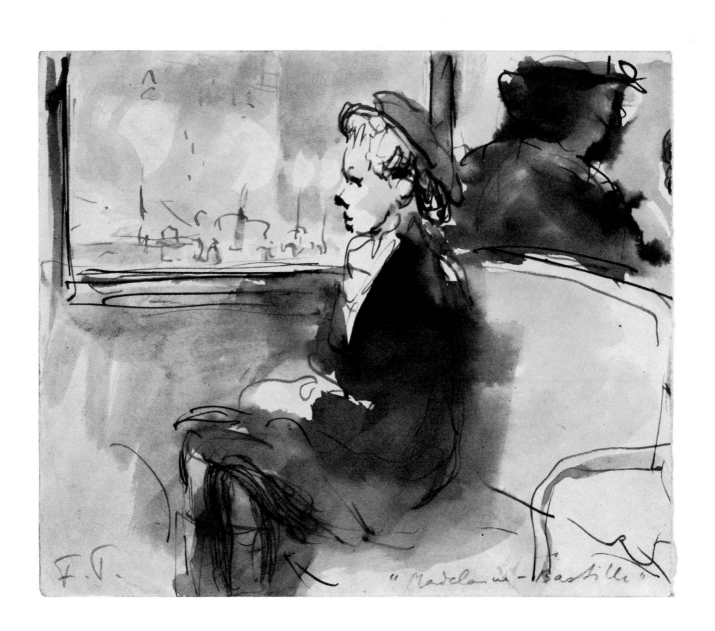

F.T. "Madeleine - Bastille"

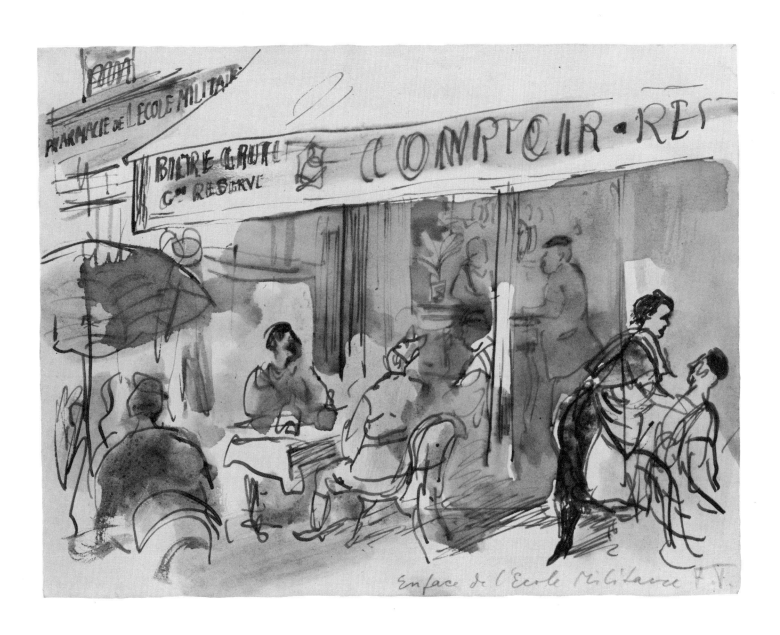

28. Rue Blondel

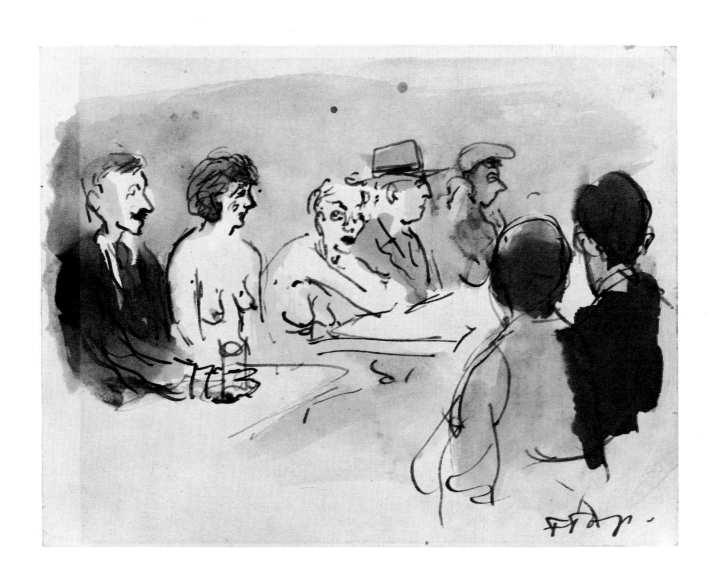

29. *Avenue Foch*

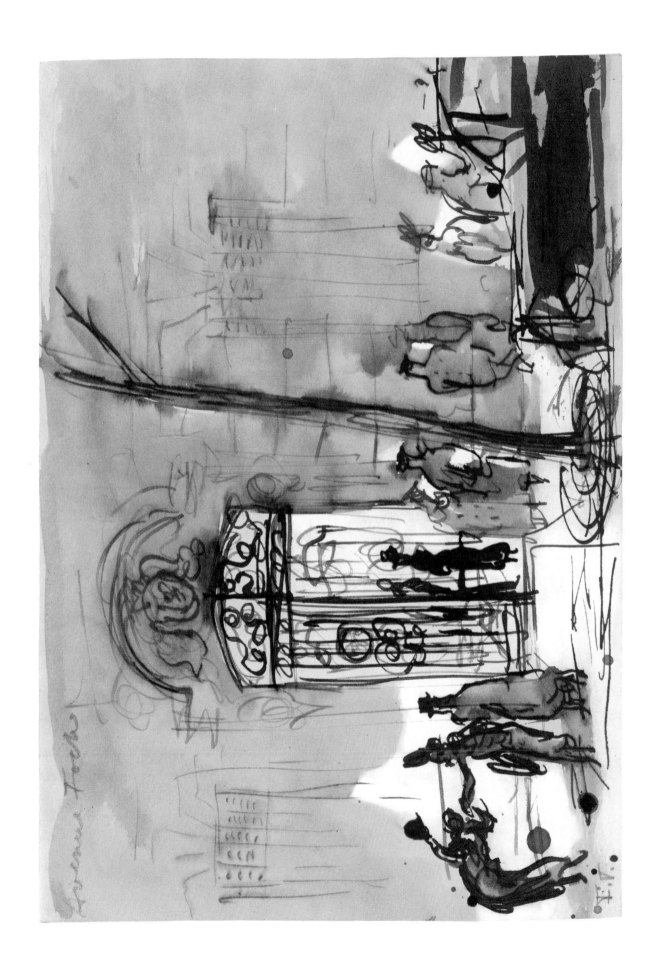

30. Bois de Boulogne

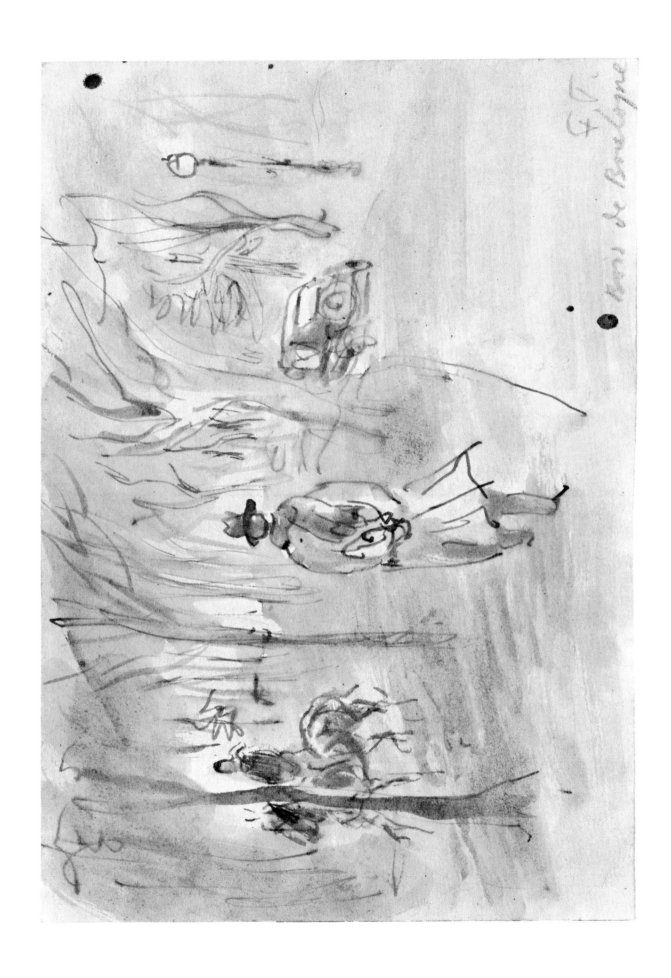

31. *Dans une boîte de nuit*

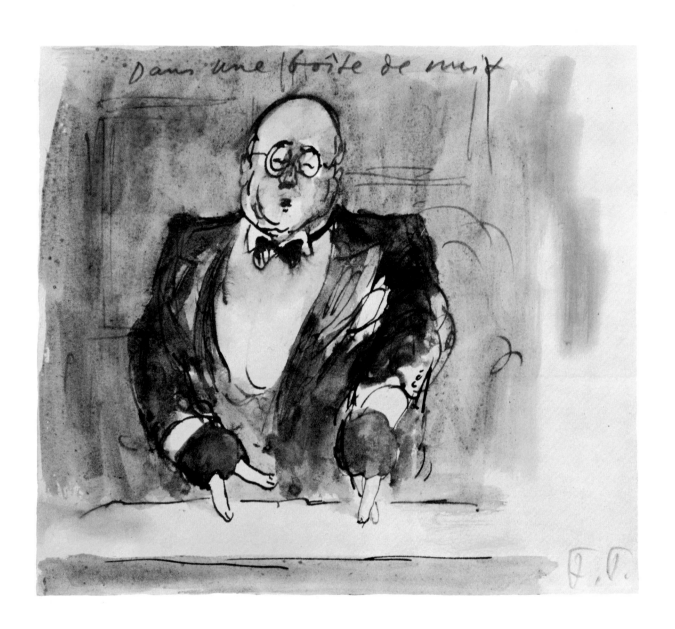

32. L' Arcade du Boul. Montmartre

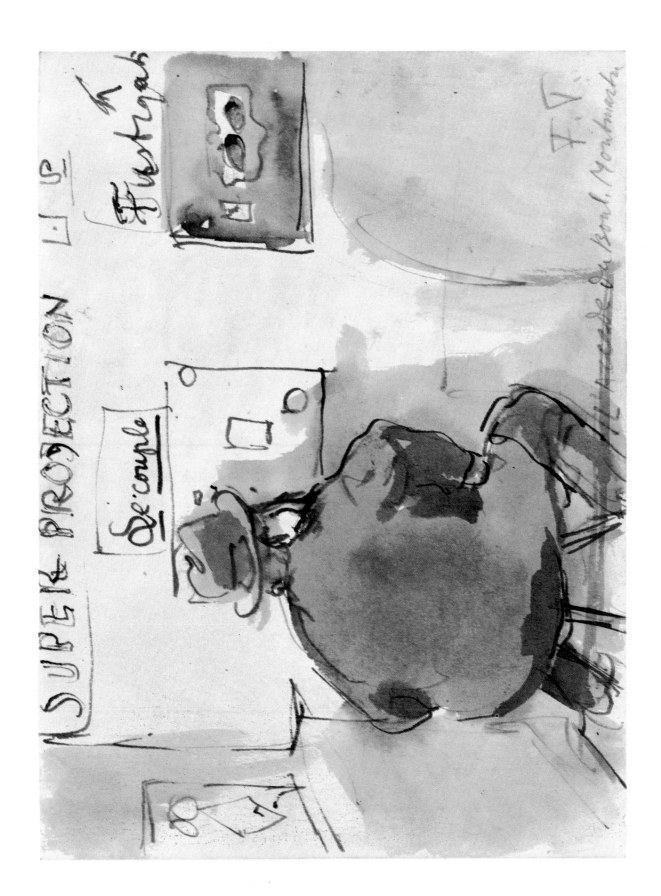

33. Champs Elysées – sous les arbres

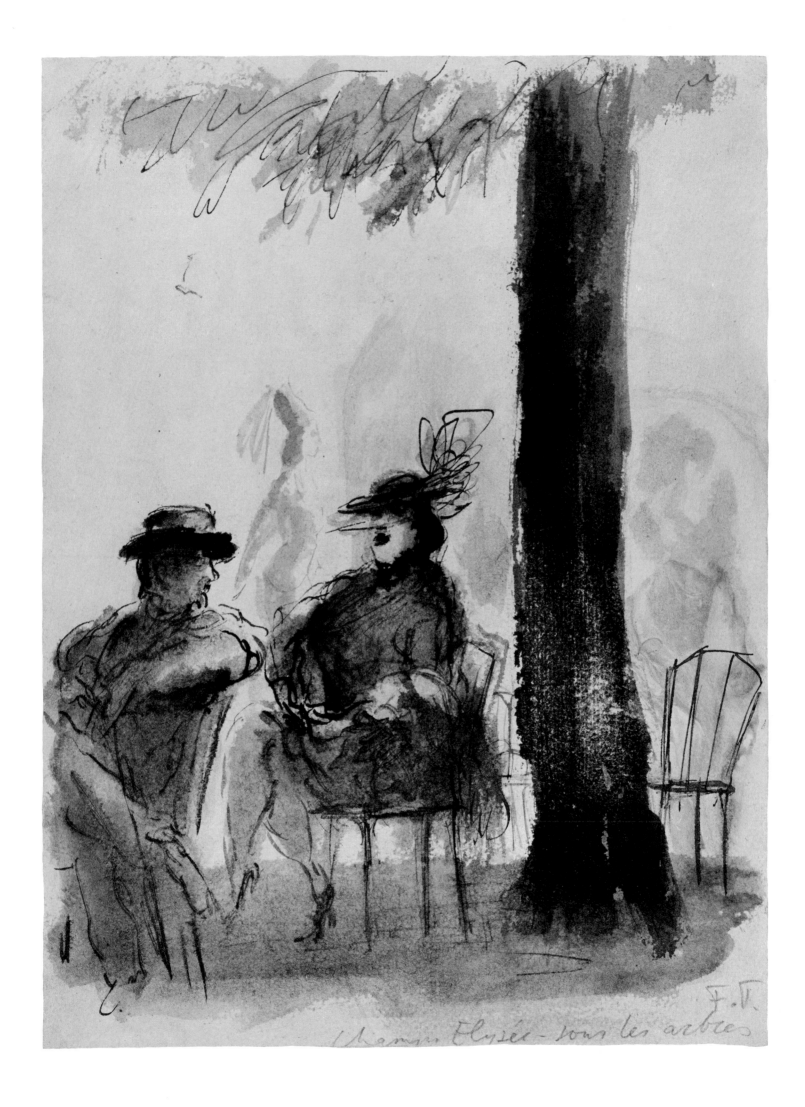

Champs Elysée - sous les arbres

34. Rue St. Denis

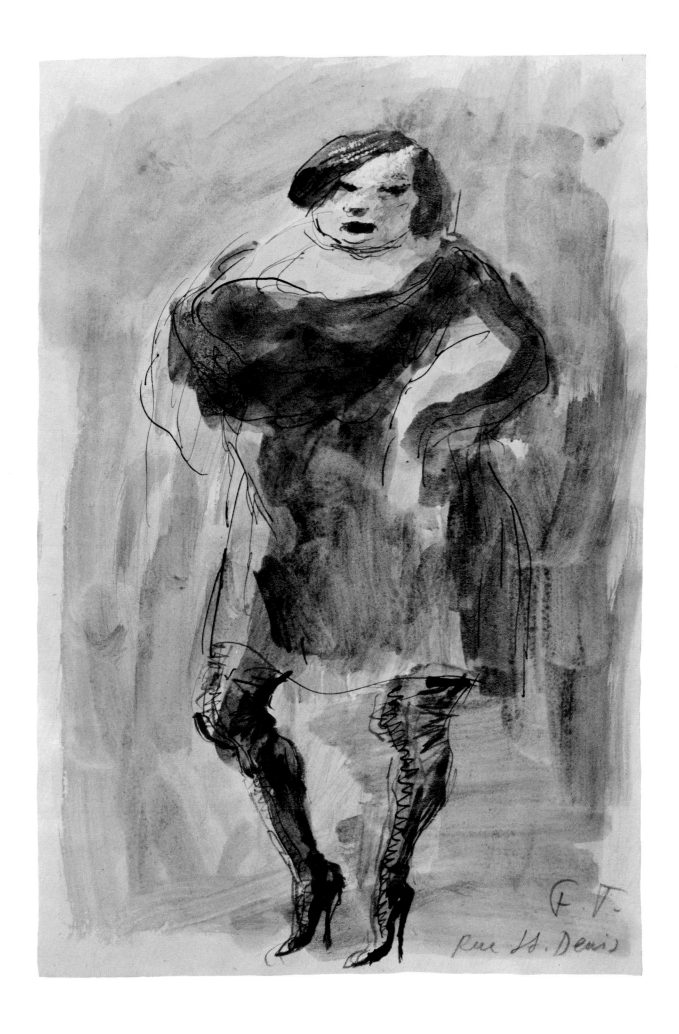

F. T.

Rue St. Denis

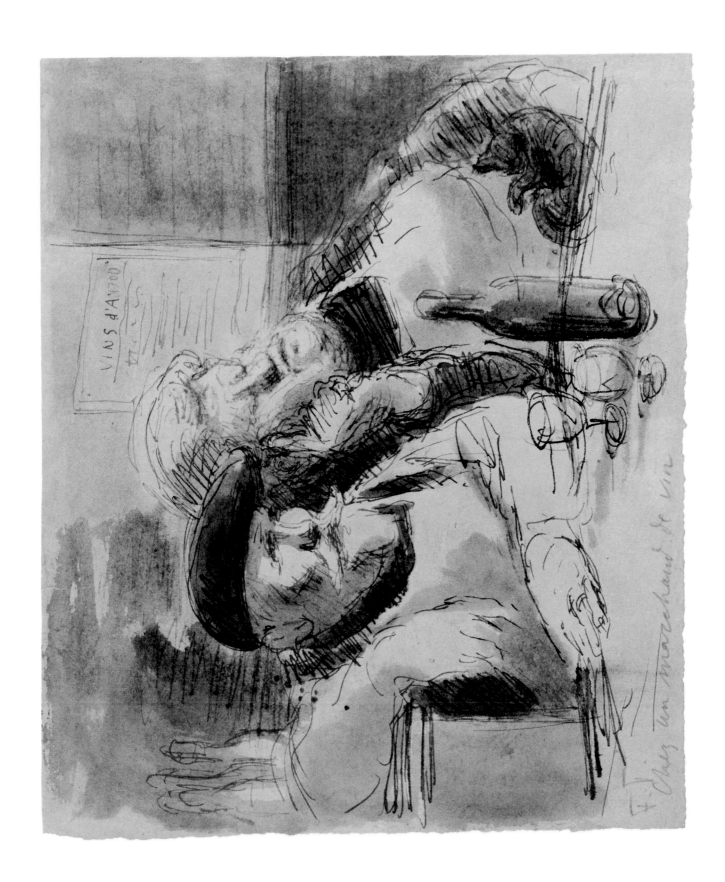

VINS d'ANJOU

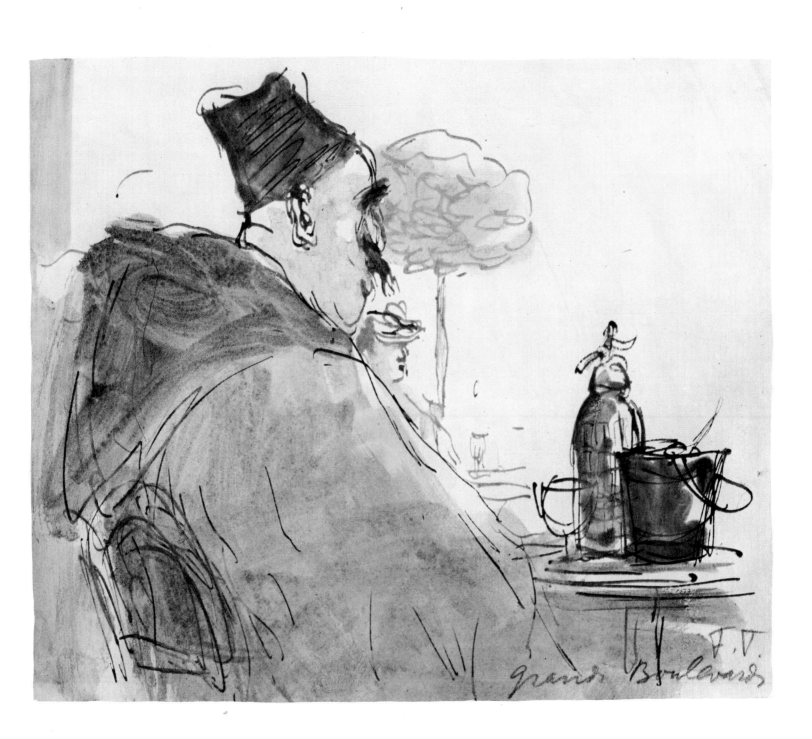

grands Boulevards

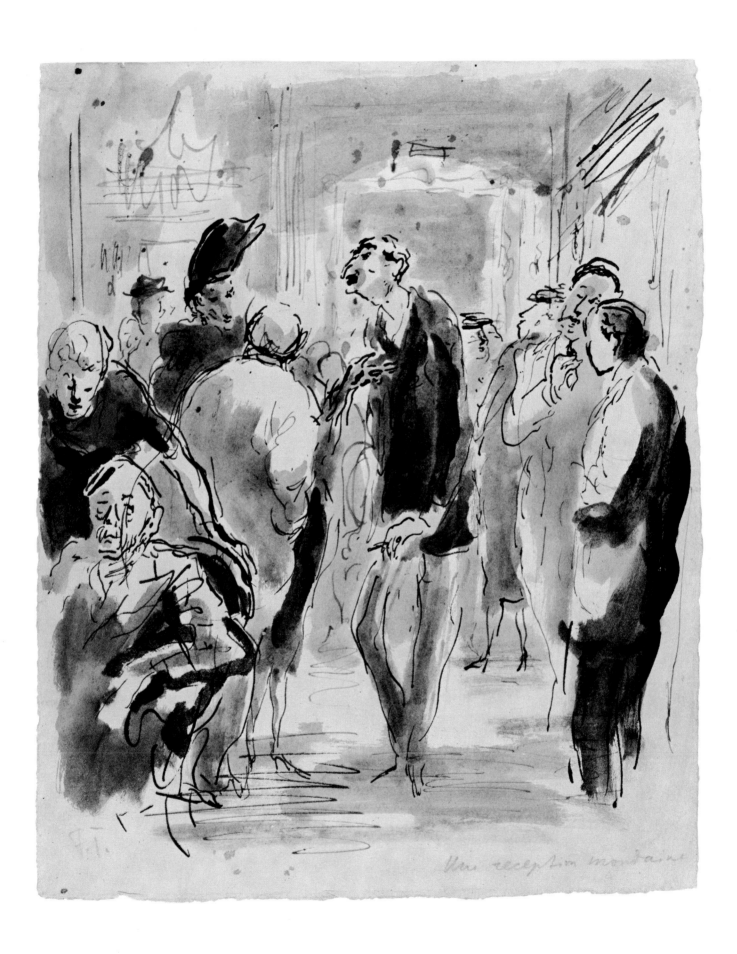

Une réception mondaine

38. Au gymnase

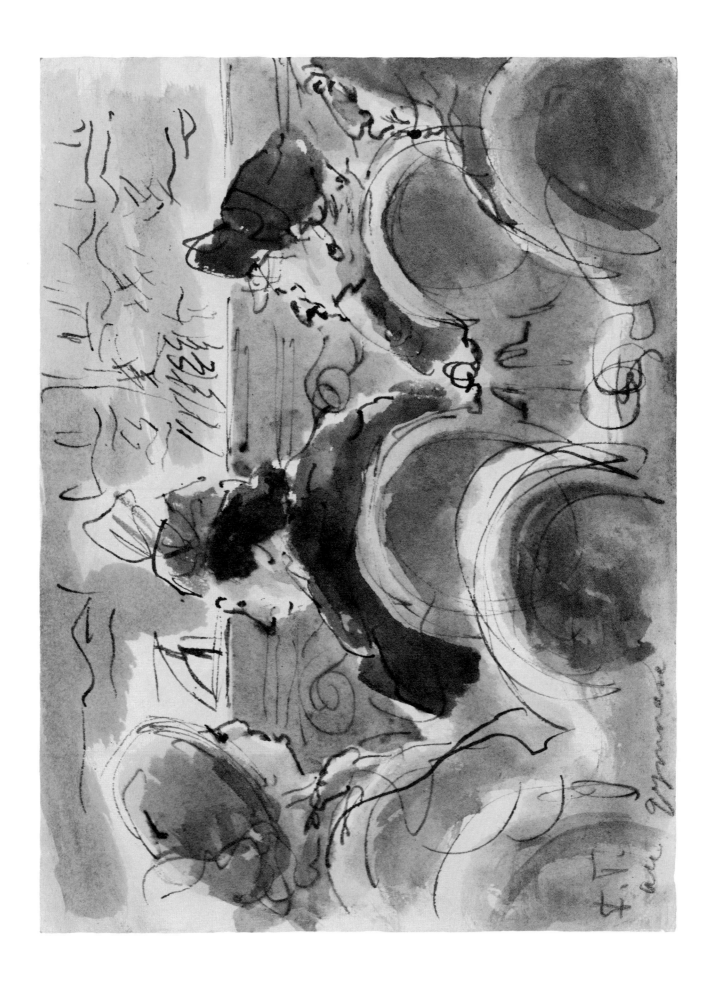

39. *Au Marché de l'Avenue de Versailles*

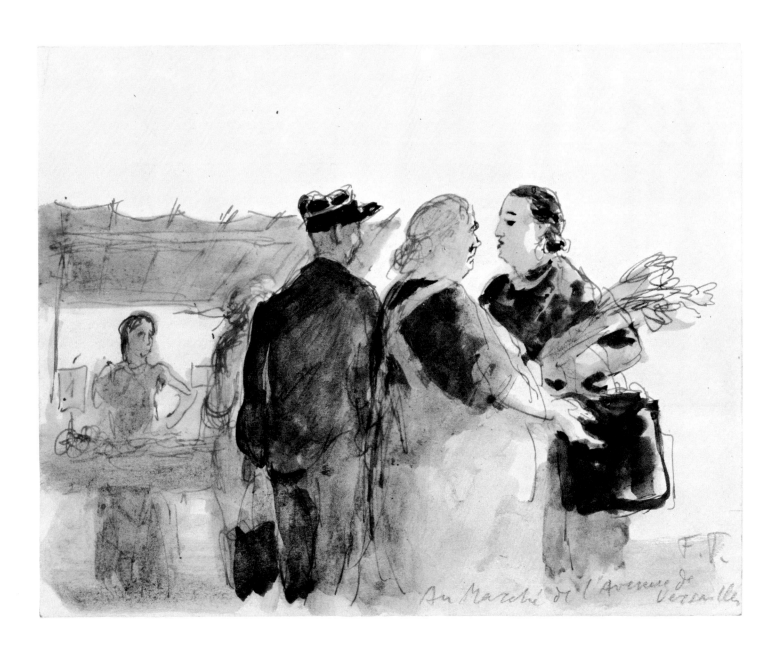

Au Marché de l'Avenue de Versailles

F. P.

40. Bd. Montparnasse

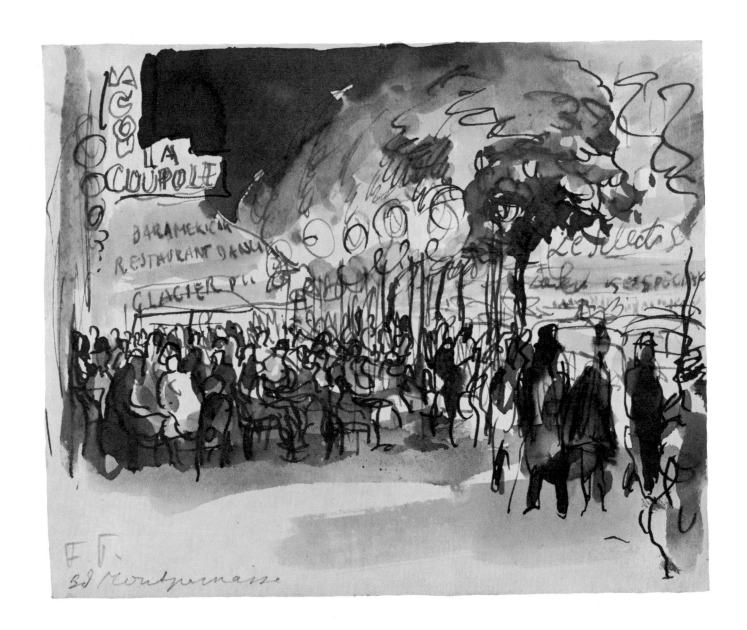

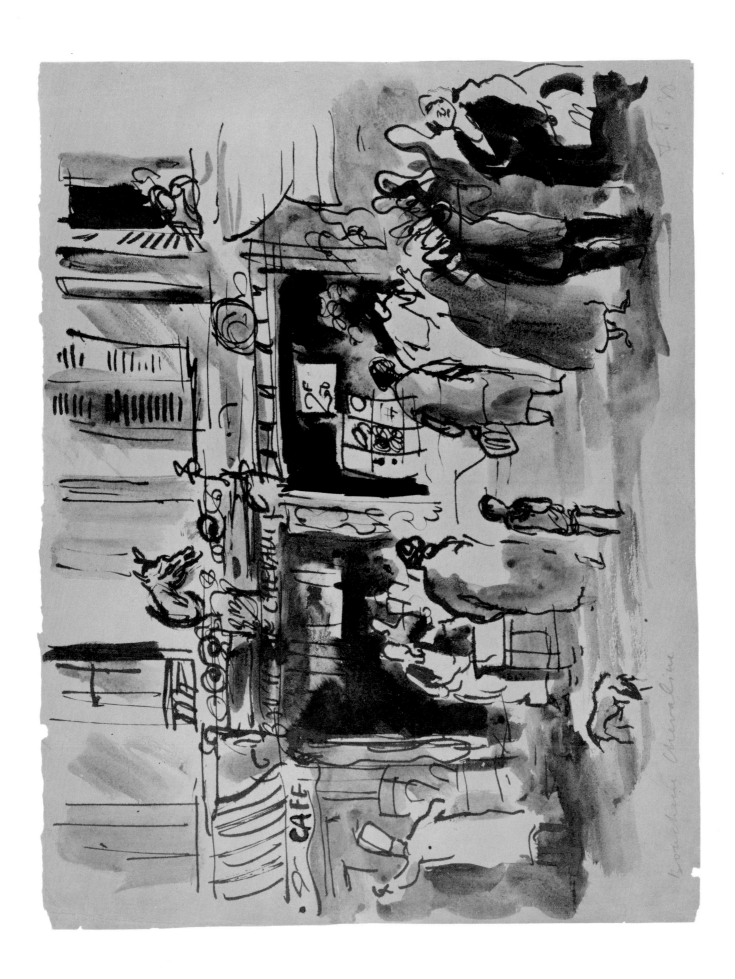

42. Rue du Faubourg St. Honoré

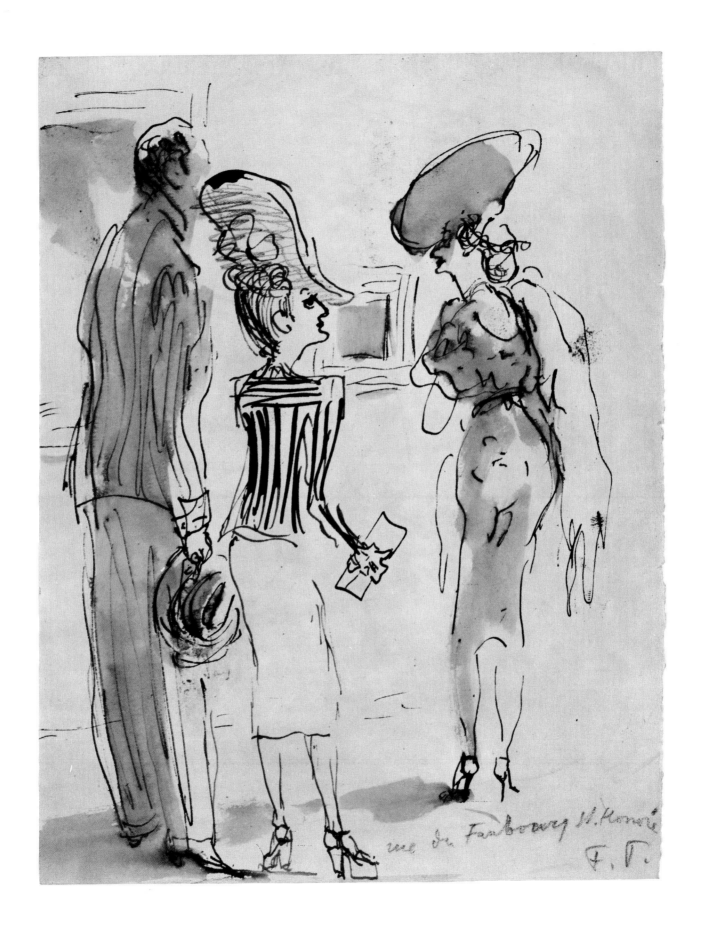

rue du Faubourg St. Honoré

F. T.

43. Bal louche

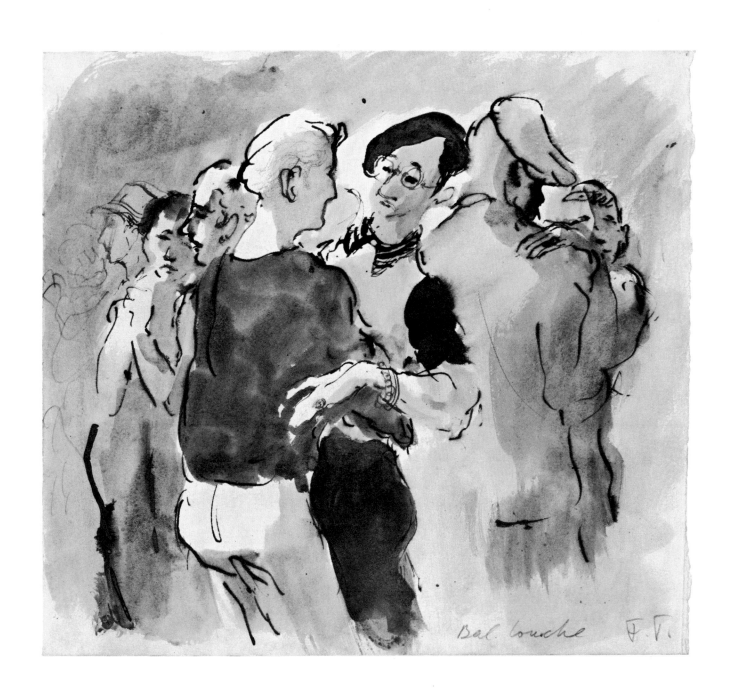

Bal touche

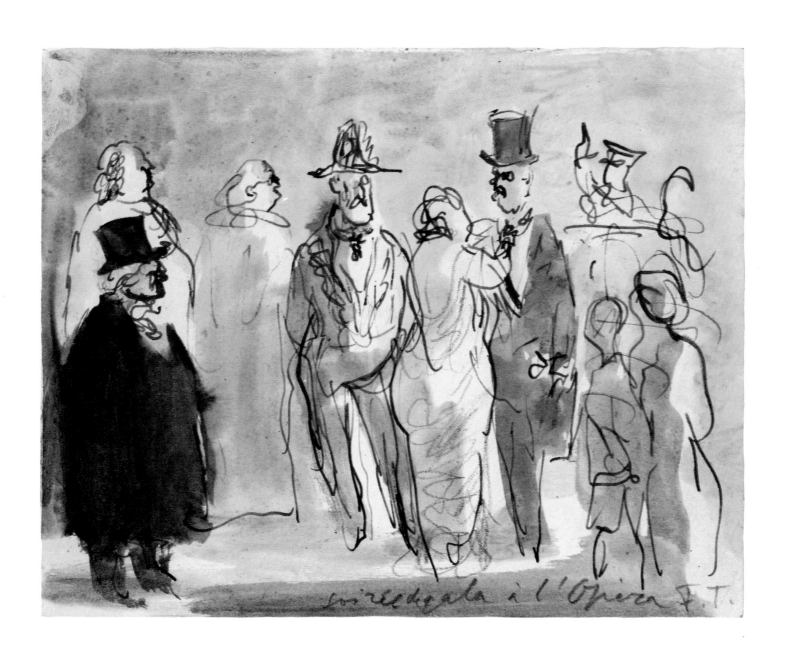

soirée gala à l'Opéra F.T.

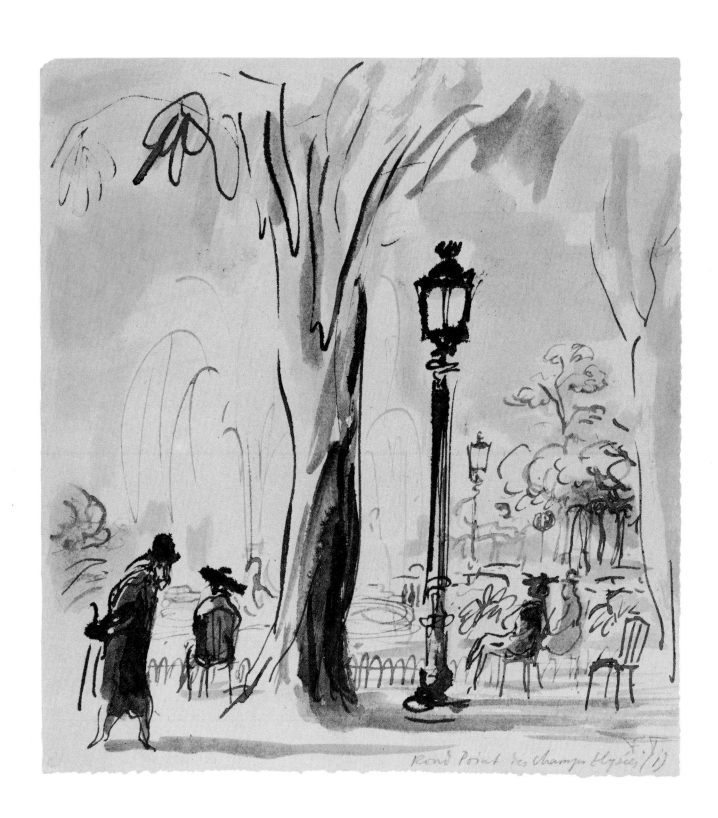

Rond Point des Champs Elysées (1)

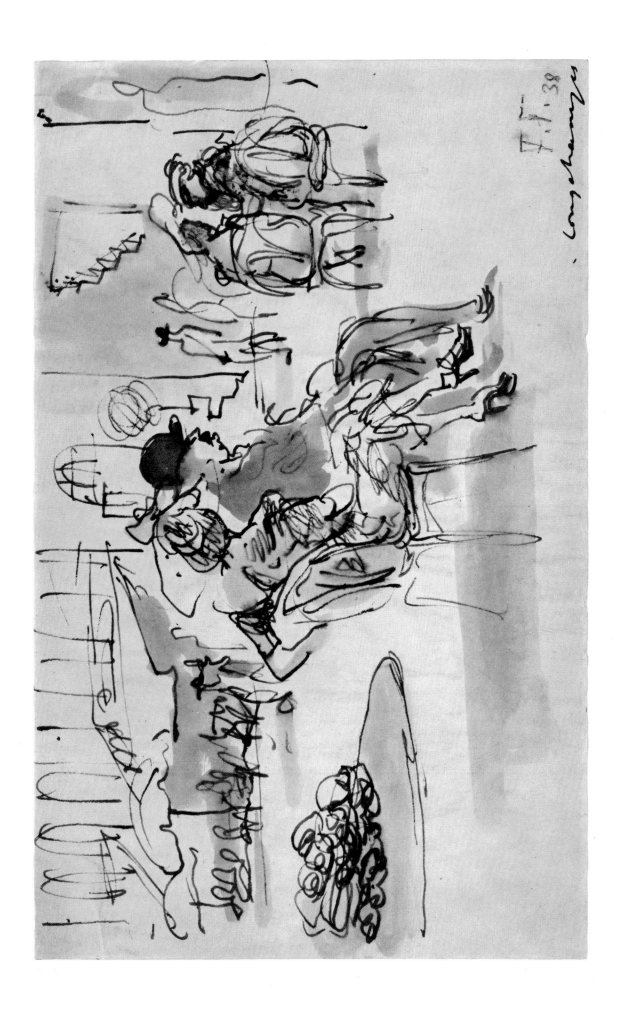

47. *Le clochard*

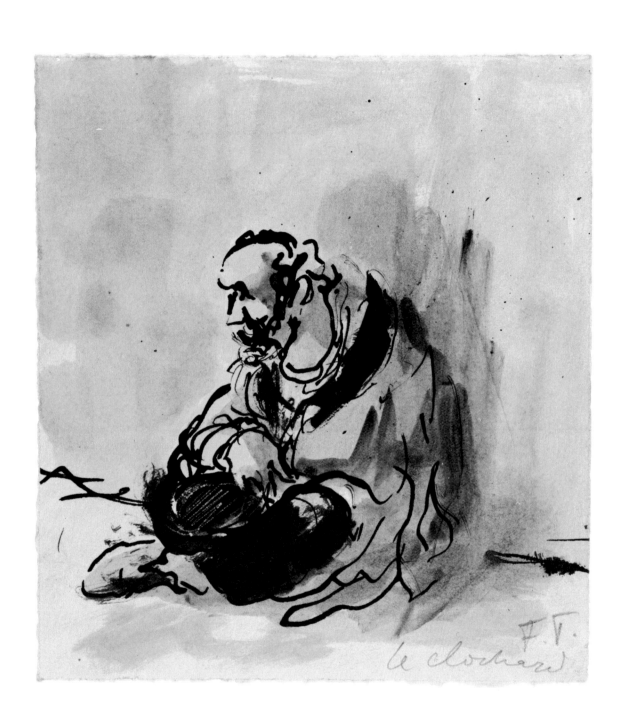

le clochard

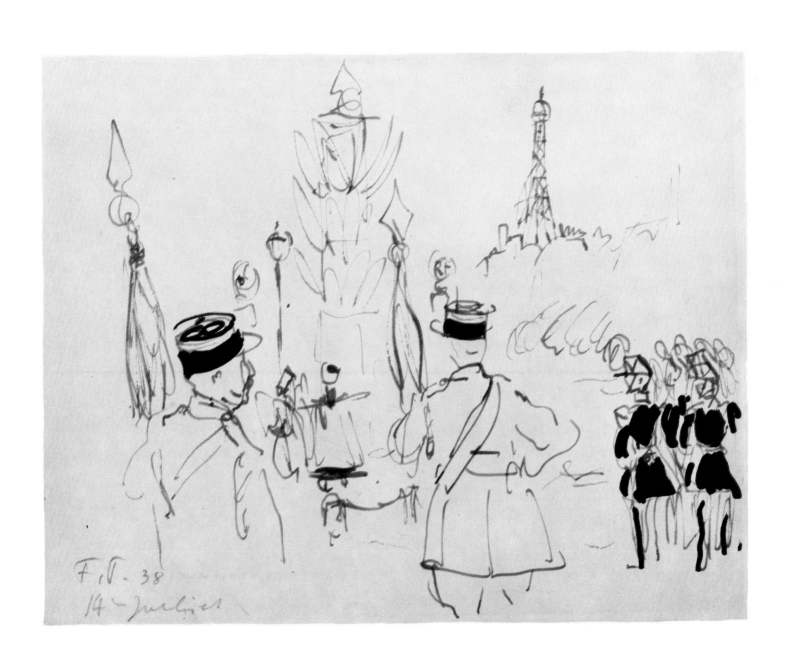

F.V. 38
14^{me} Juillet

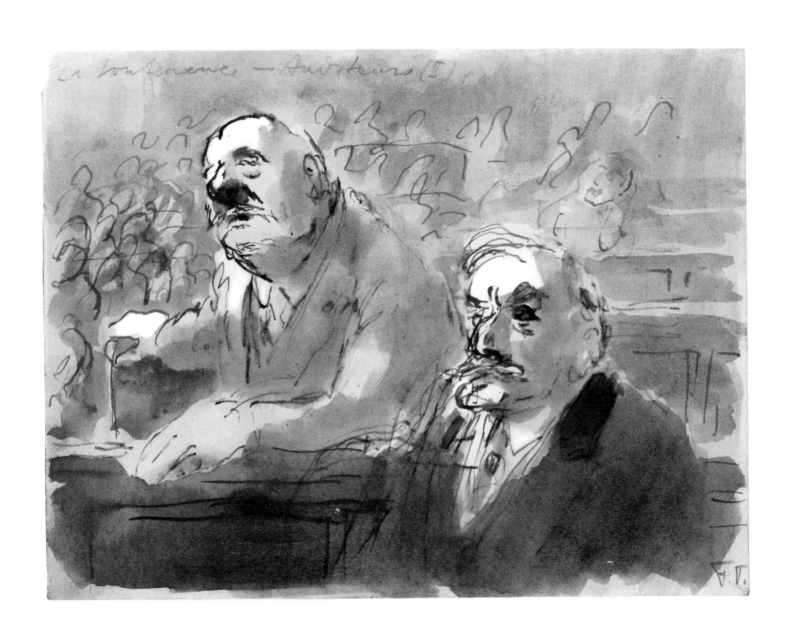

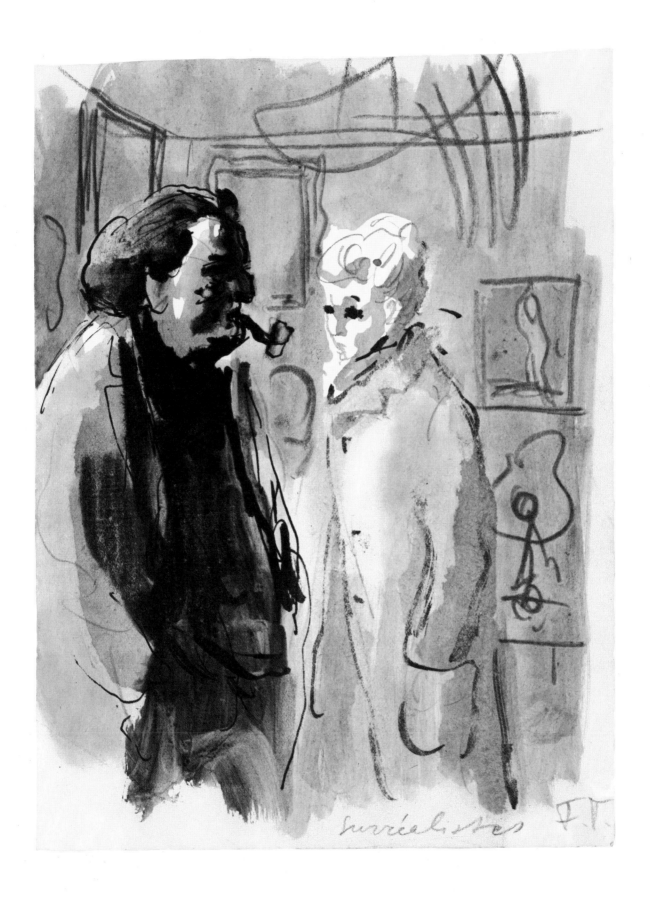

surréalistes FT

51. *Le Président de la Chambre*

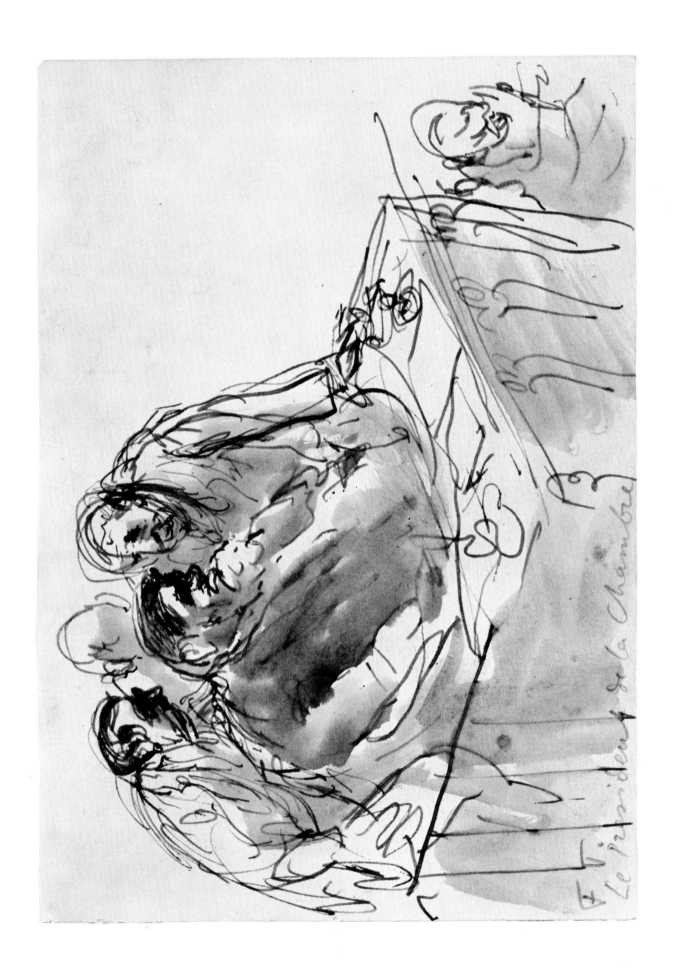

Le Président de la Chambre

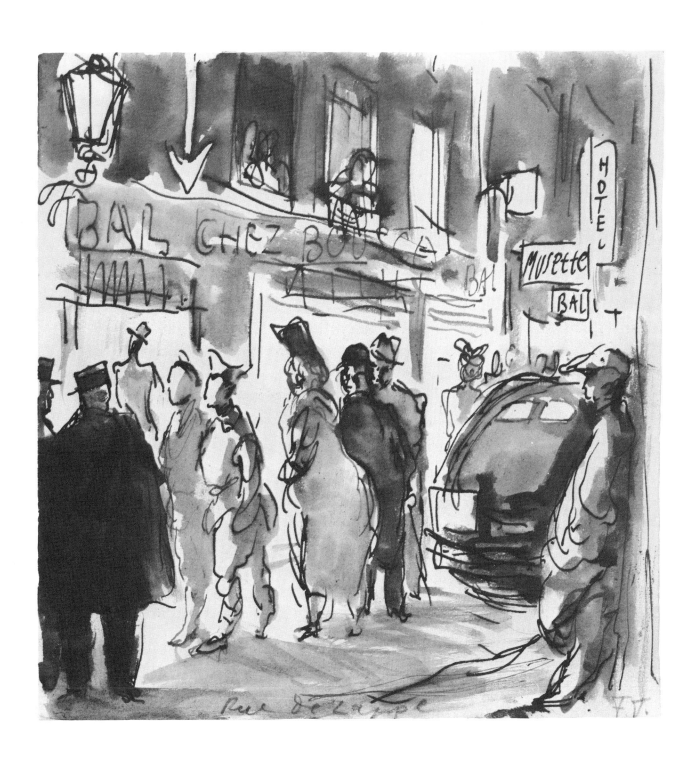

Rue de Lappe

53. Bal Musette (II)

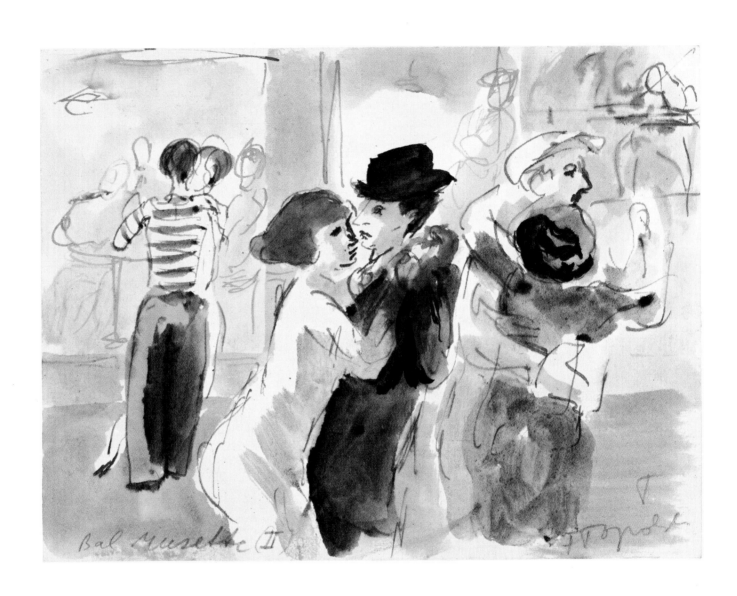

Bal Musette II

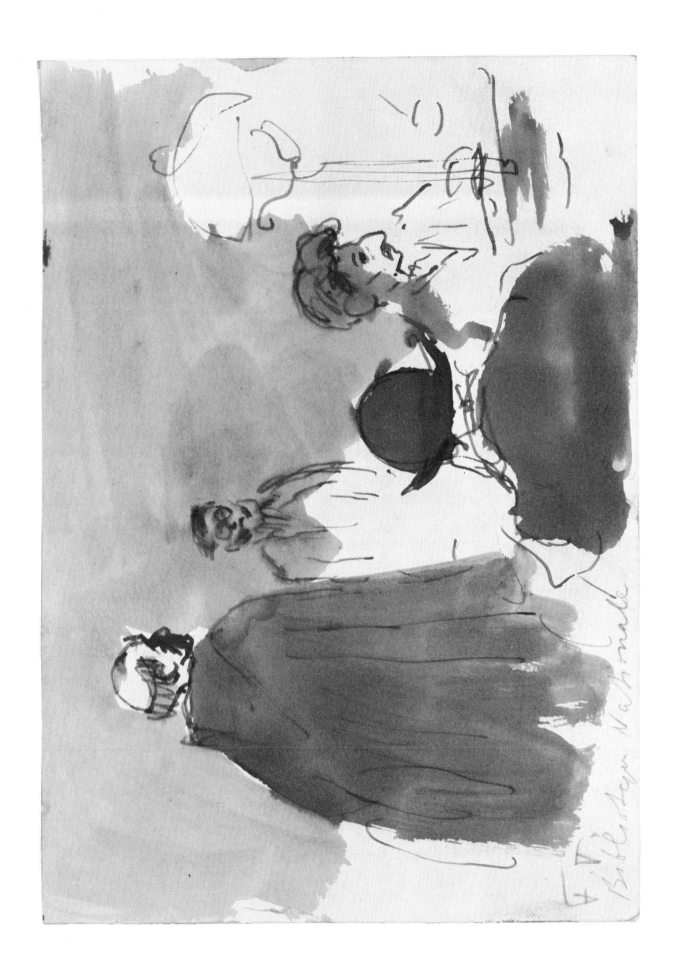

55. *Le Gala à l'Hôtel de Ville*

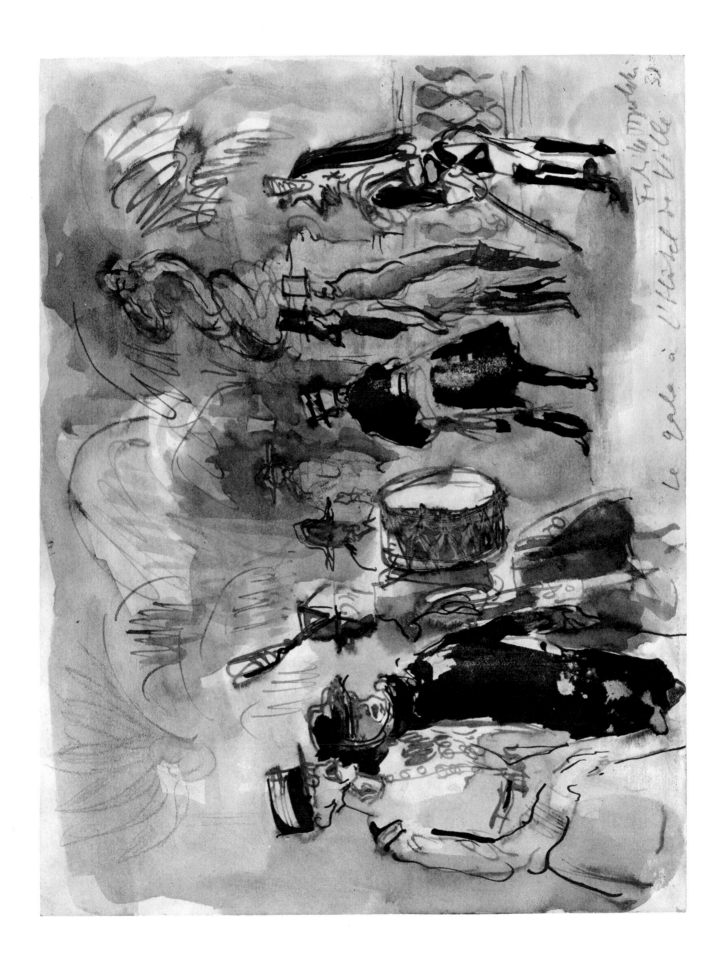

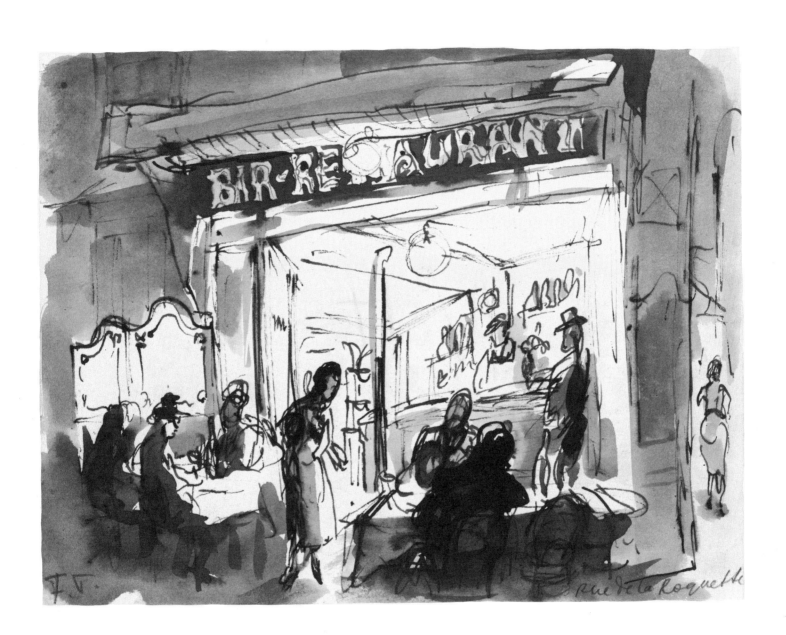

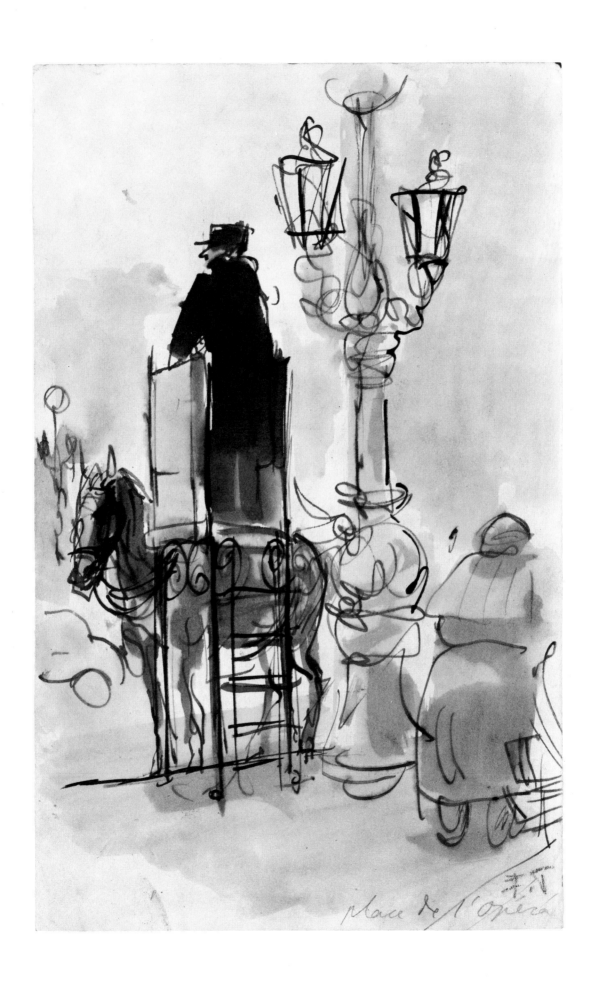

Place de l'Opéra

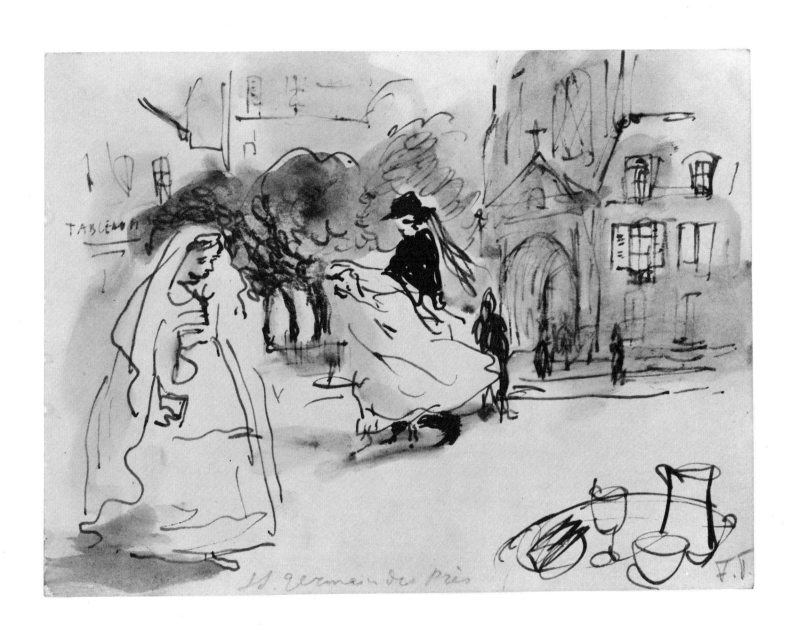

59. *Quai de Béthune*

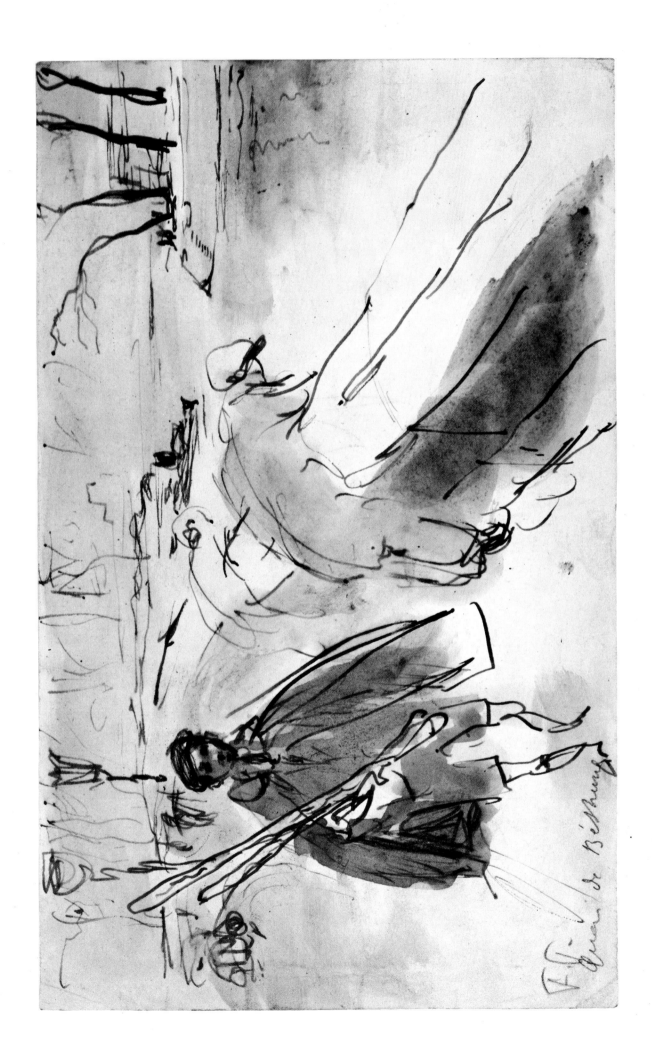

60. ''five o'clock'' à l'Hotel George V

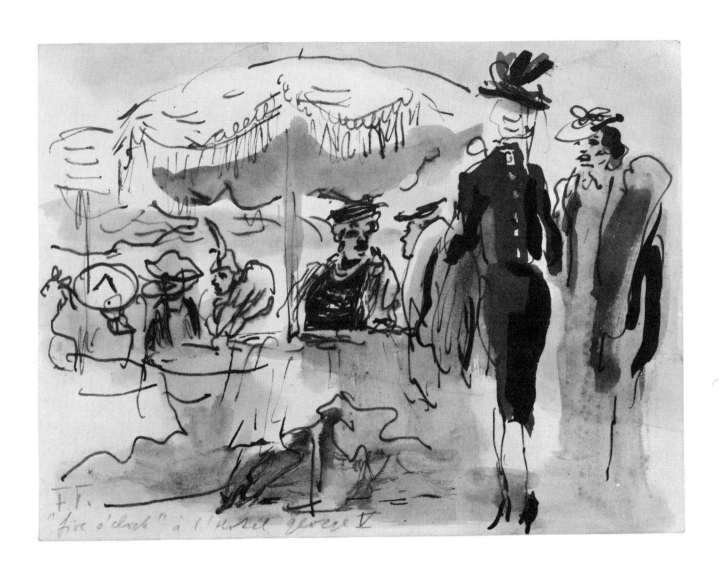

"five o'clock" à l'Hôtel George V

61. *A l'Opéra*

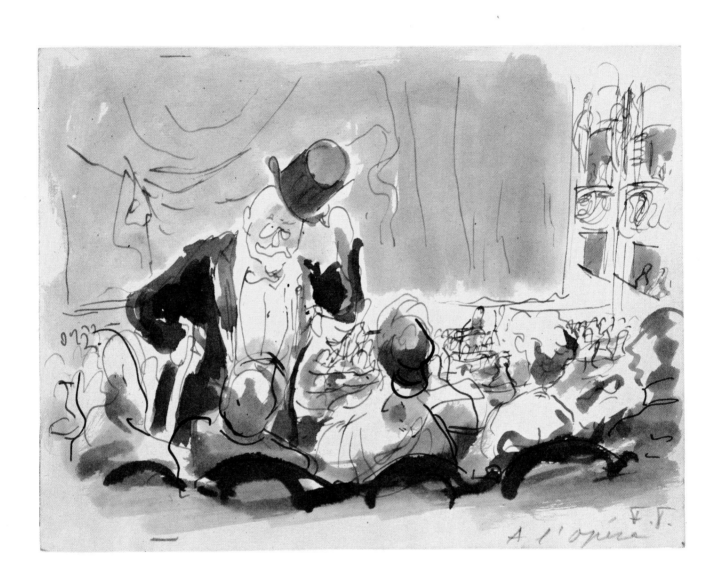

A l'opéra

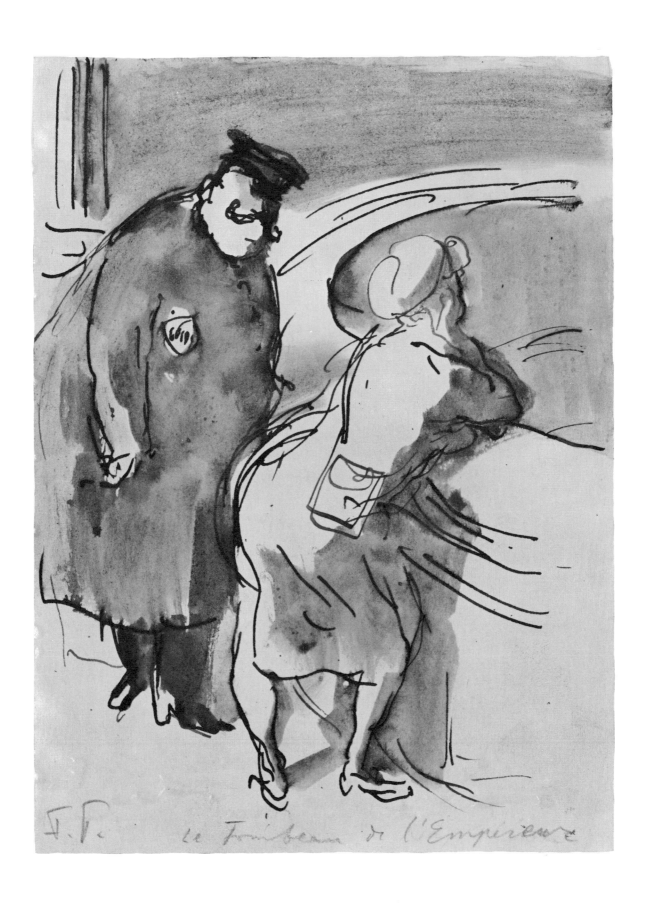

Le Tombeau de l'Empereur

63. *L'Eglise St. Germain des Près*

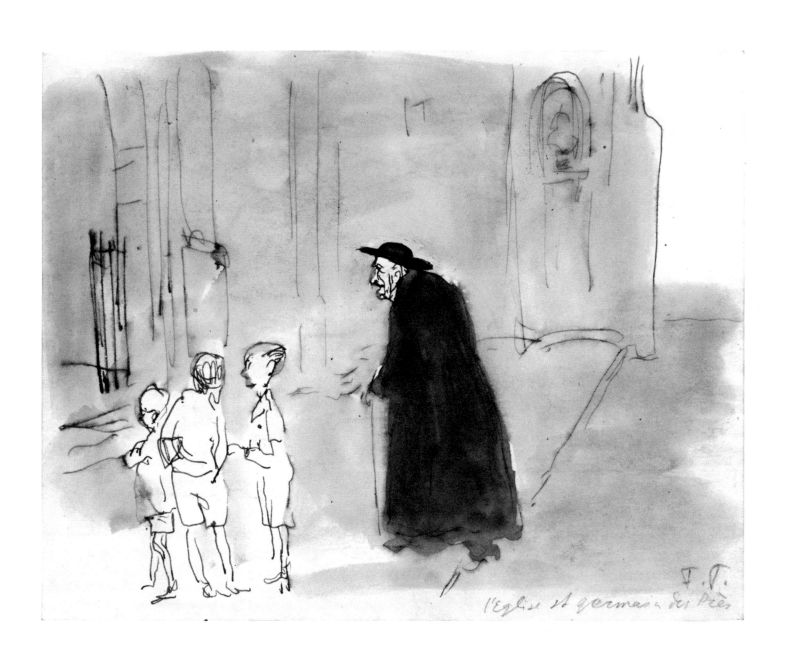

l'Eglise st germain des Prés

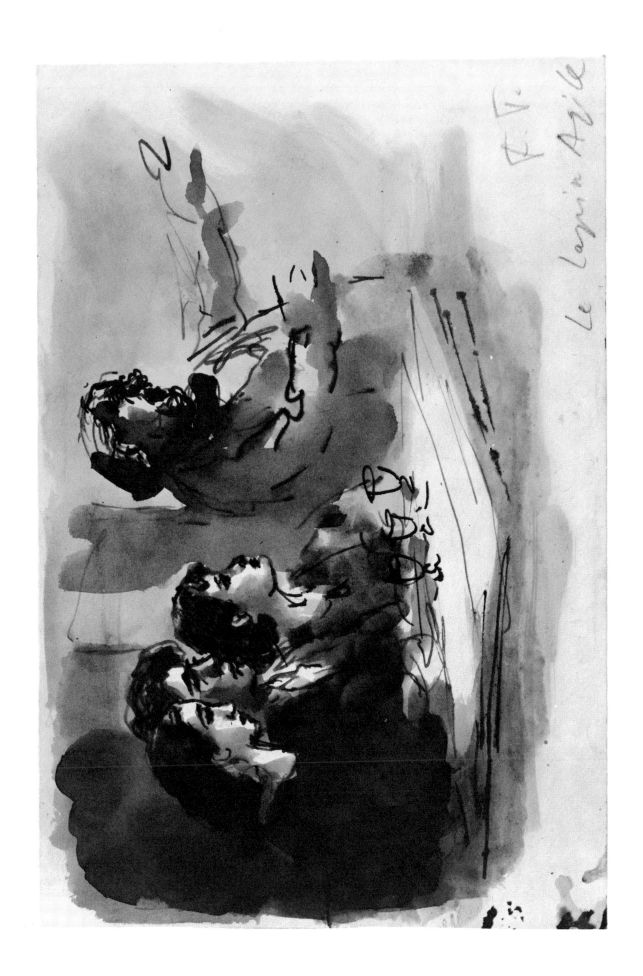

Le lapin Agile

65. *Casino de Paris*

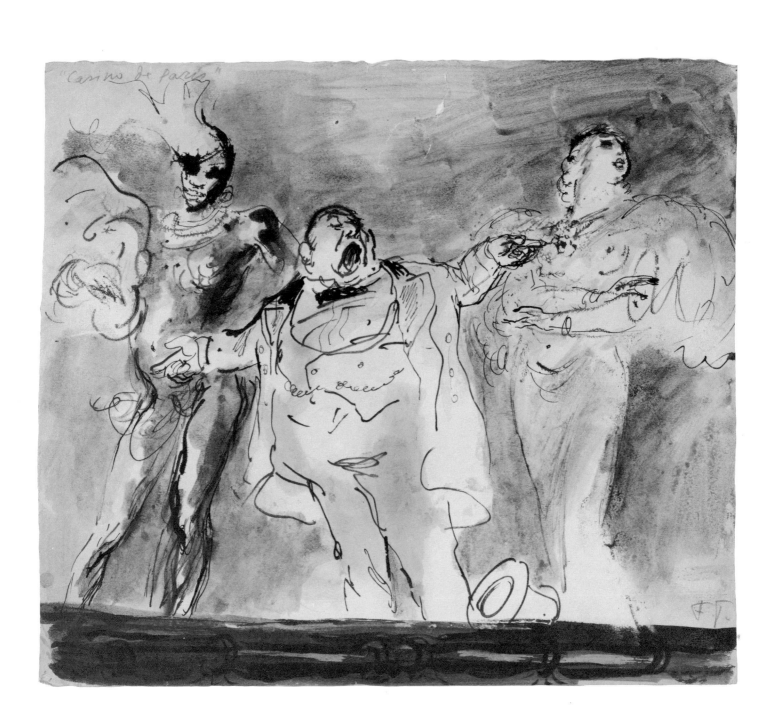

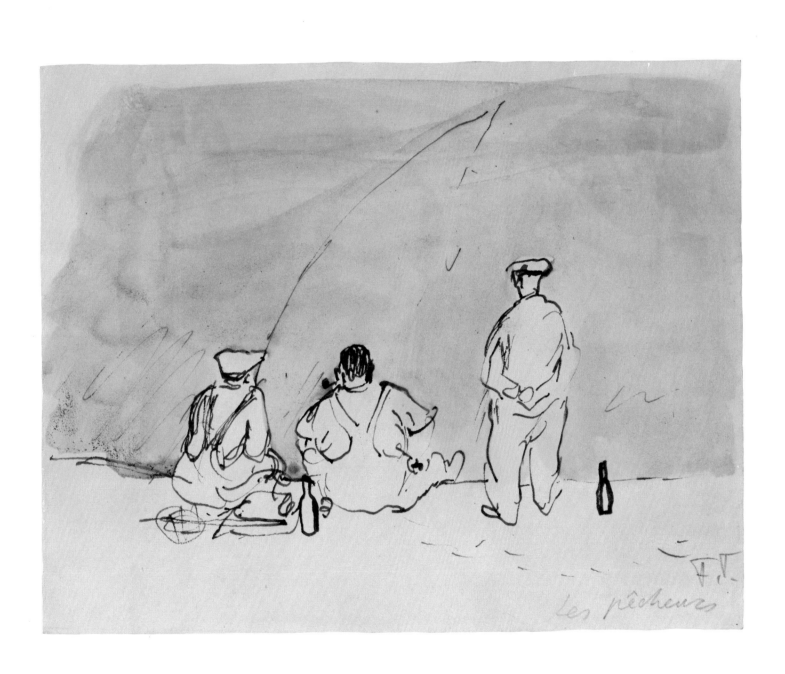

Les pêcheurs

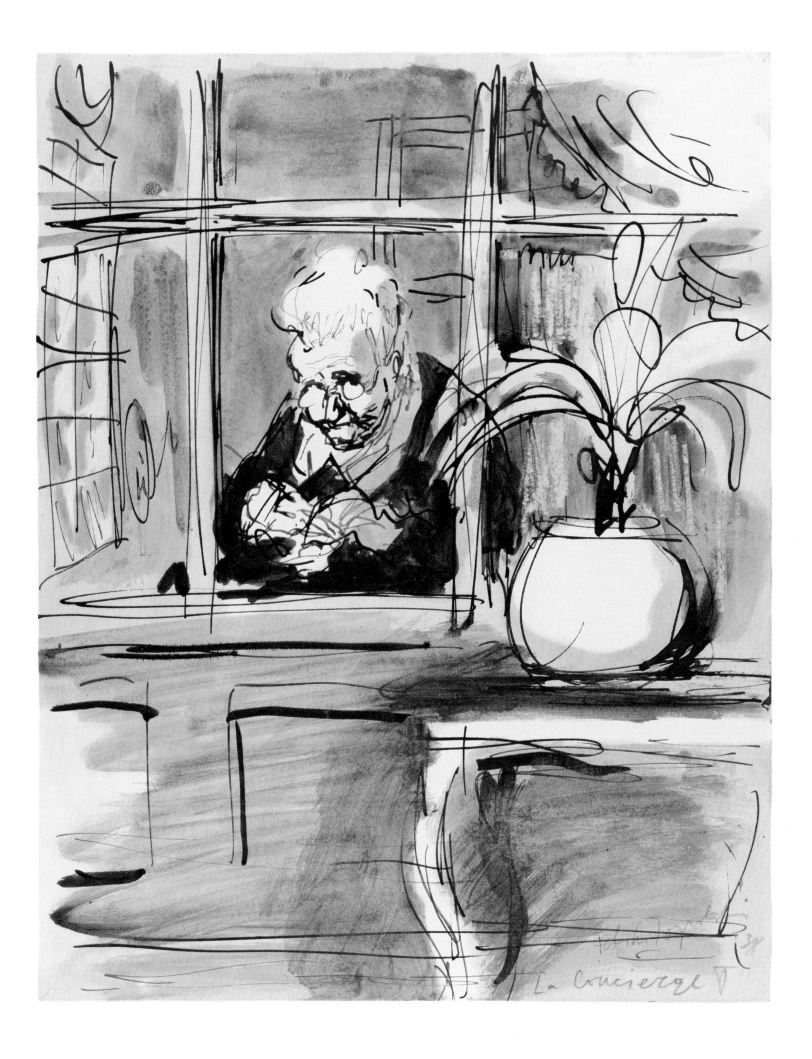

La Concierge

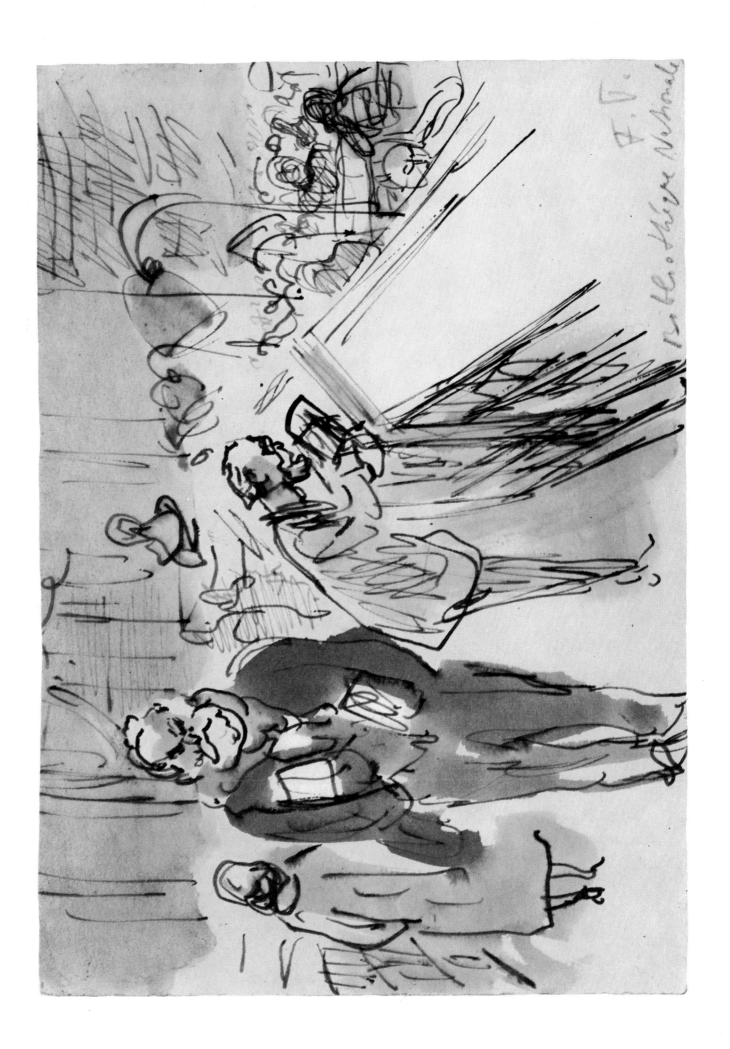

69. A l'entrée de Notre Dame

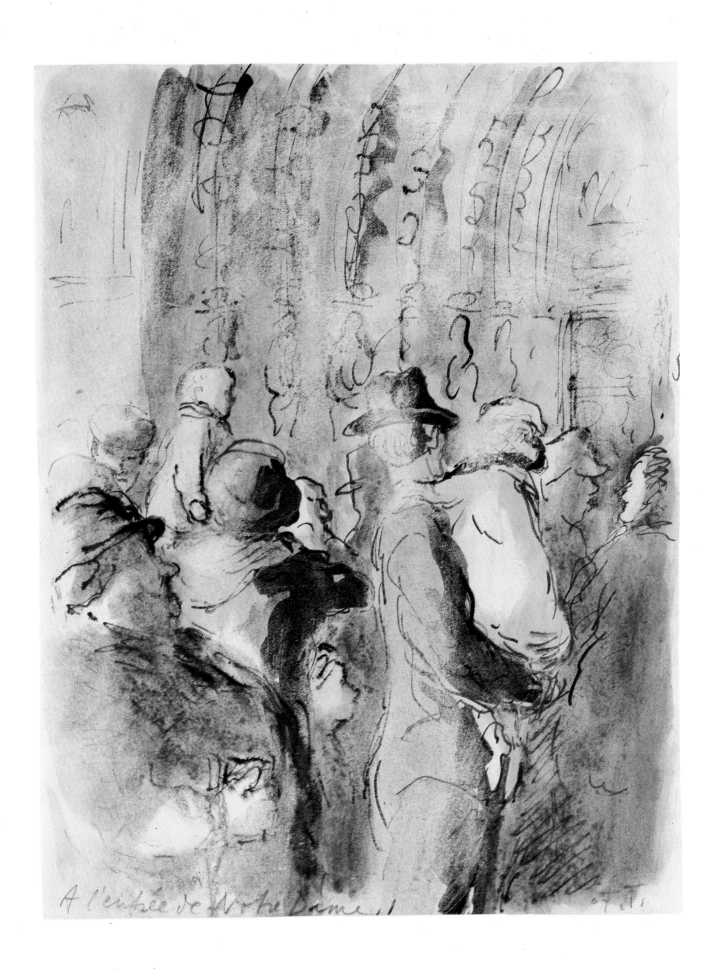

A l'entrée de Notre Dame

70. *Rue des Halles*

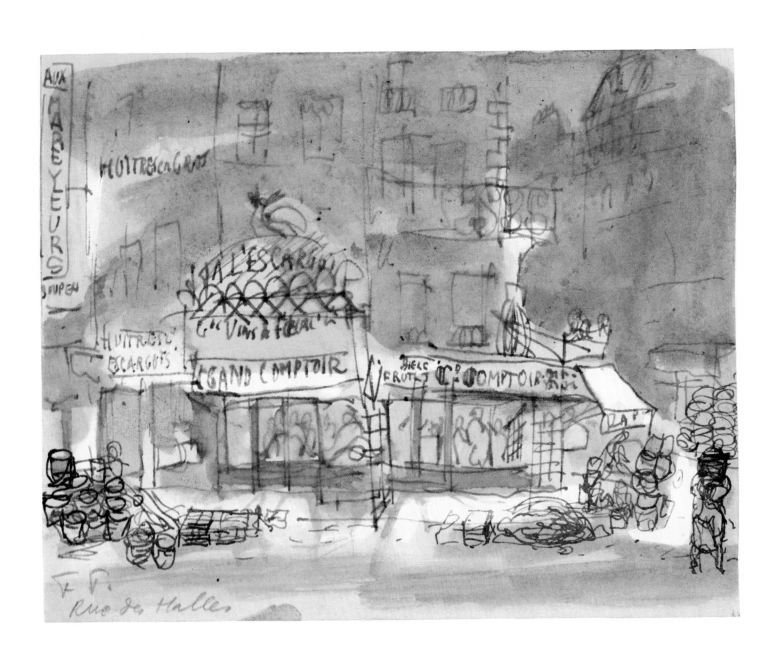

AUX
MAREYEURS
HUITRES ESCARGOTS
A L'ESCARGOT
Cᵉ "Vins de Fleurie"
HUITRES ESCARGOTS
GAND COMPTOIR
BELLE FRUITS Cᵈ COMPTOIR

F.P.
Rue des Halles

71. 'Entre-acte à la Salle Pleyel'

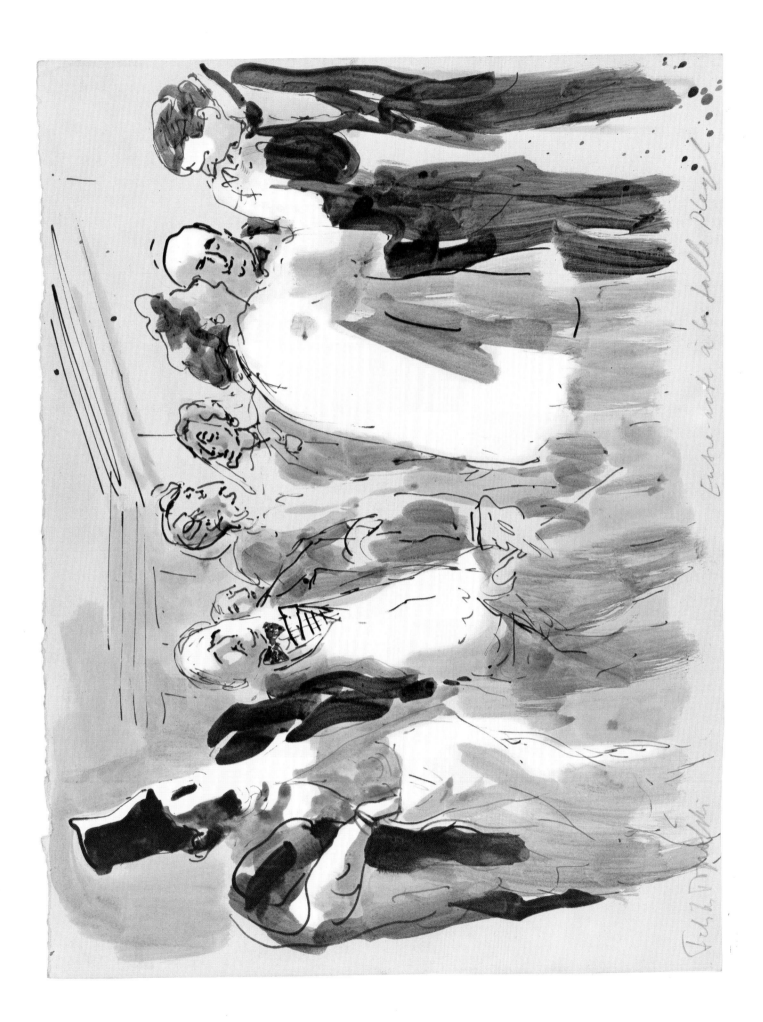

72. *Grand Palais*

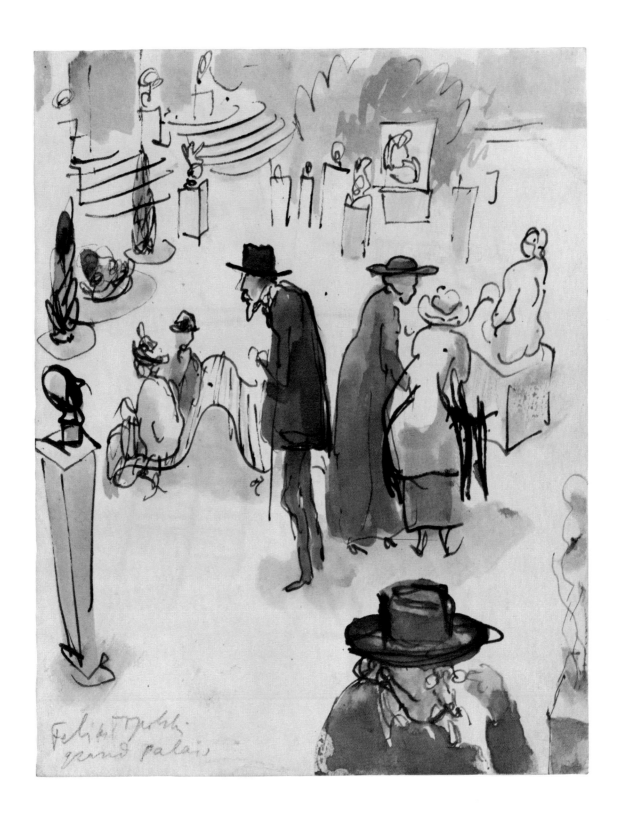

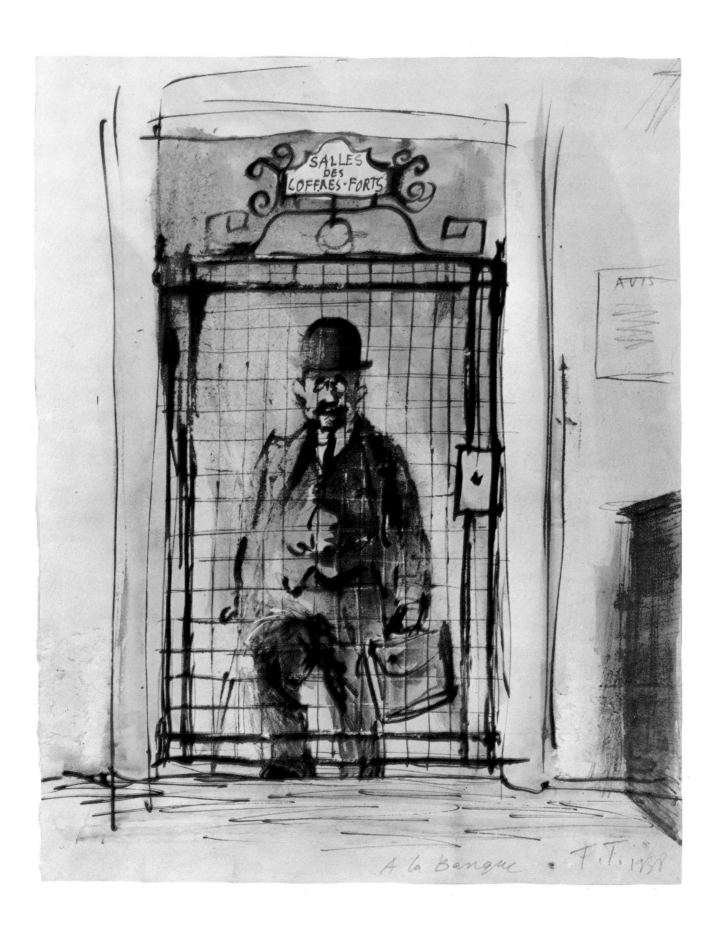

SALLES
DES
COFFRES-FORTS

AVIS

A la Banque

74. Palais Bourbon

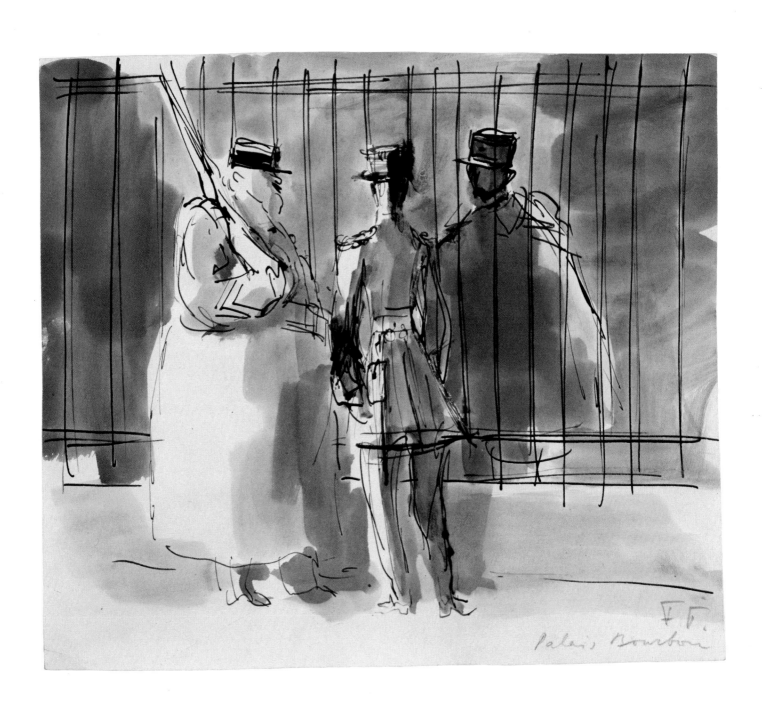

Palais Bourbon

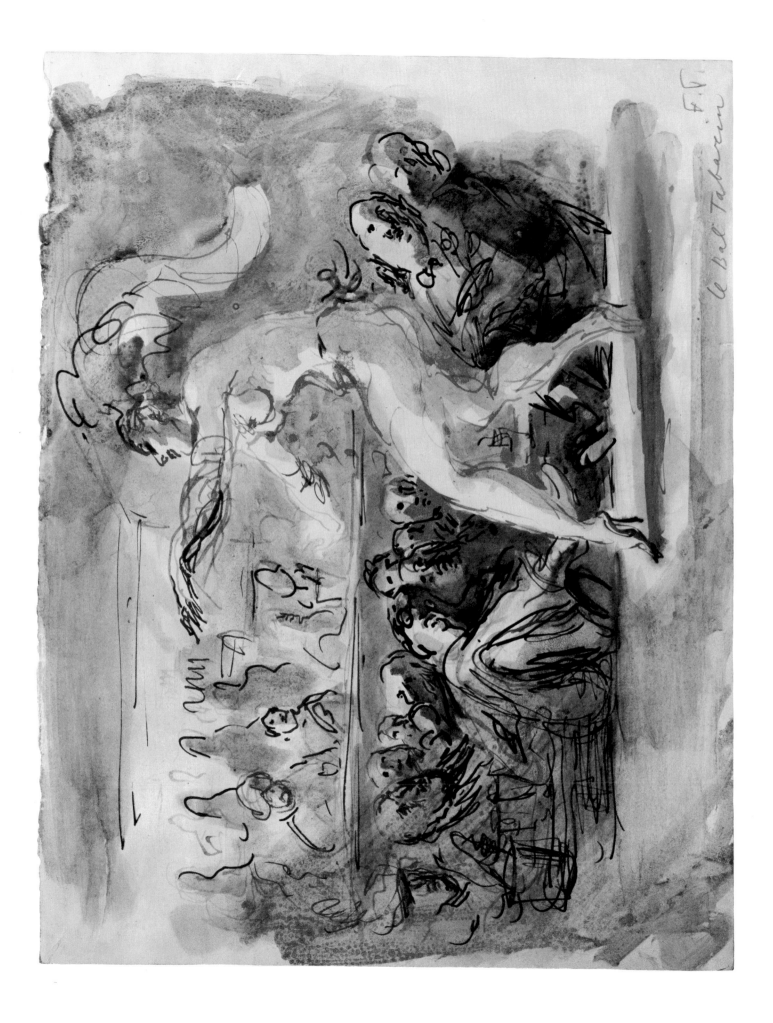

Le Bal Tabarin

F. V.

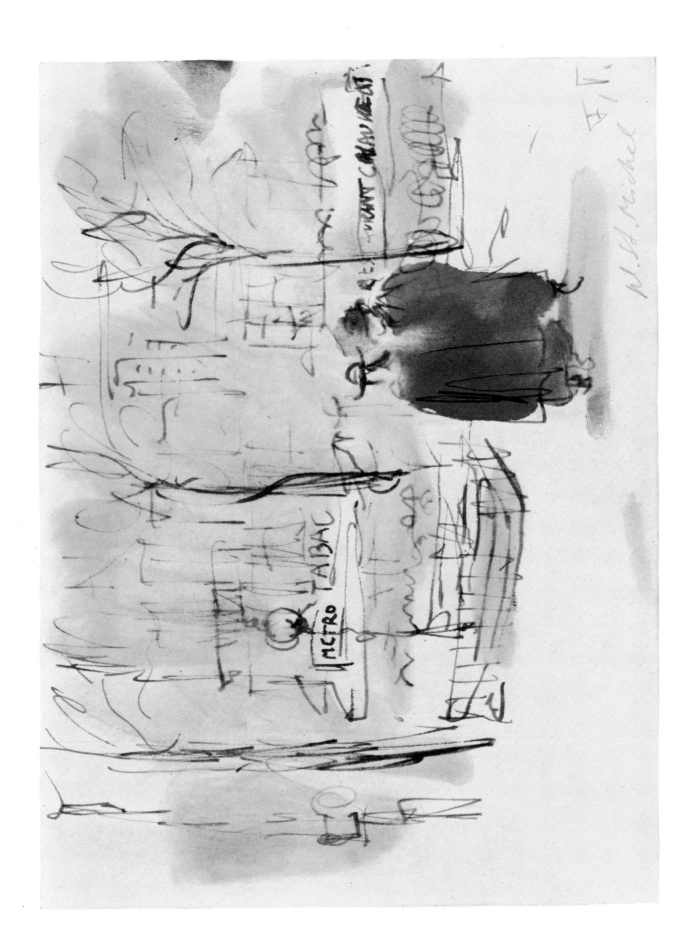

77. Un fort des Halles

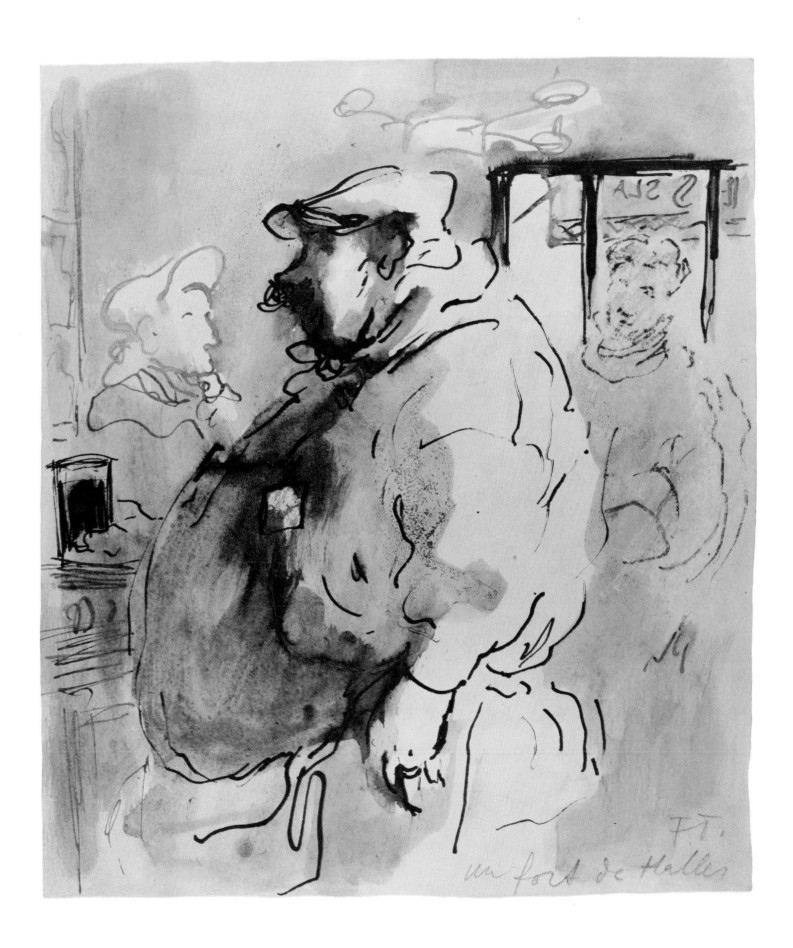

un fort de Halles

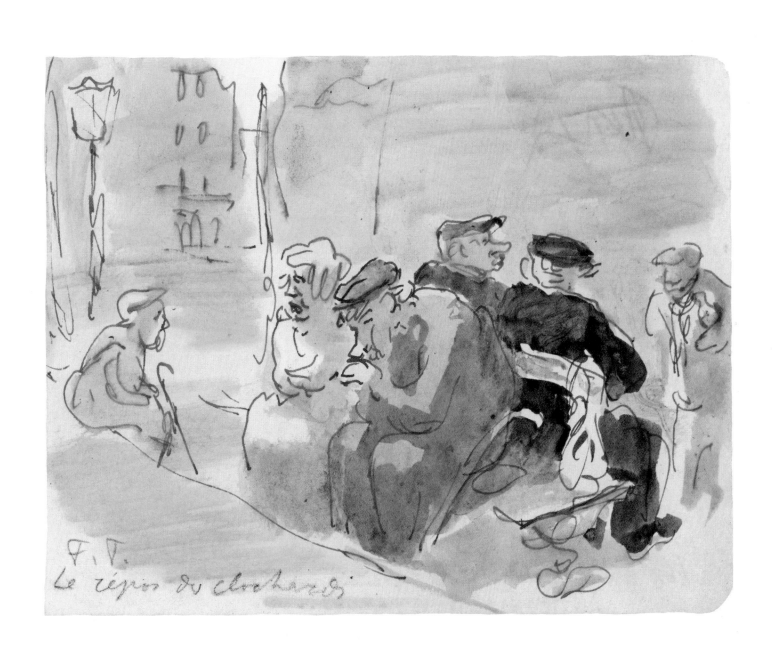

F.T.
Le repos des clochards

79. *Café du Dôme*

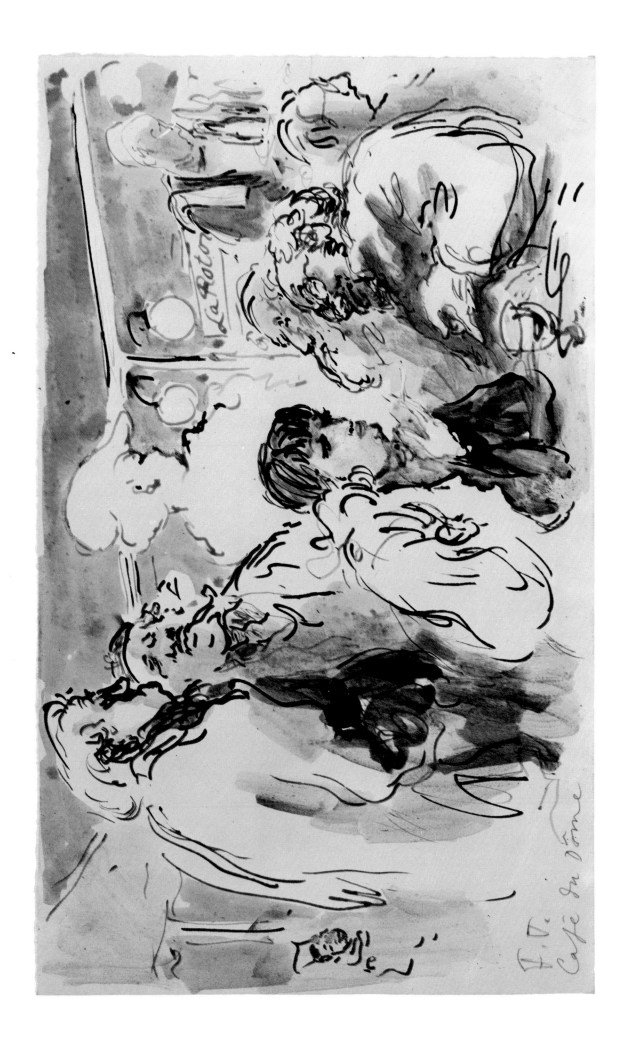

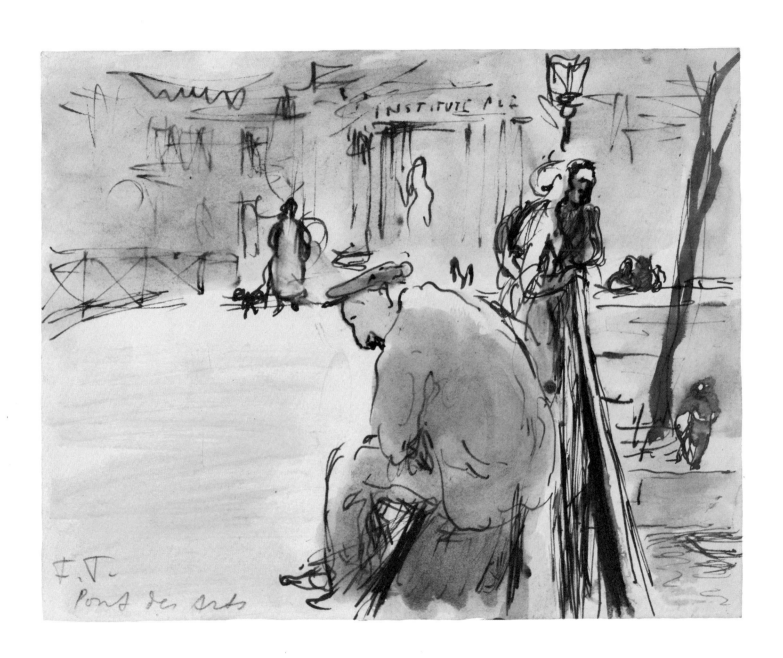

INSTITUTE ALe

F.T.
Pont des arts

81. Chez Nina

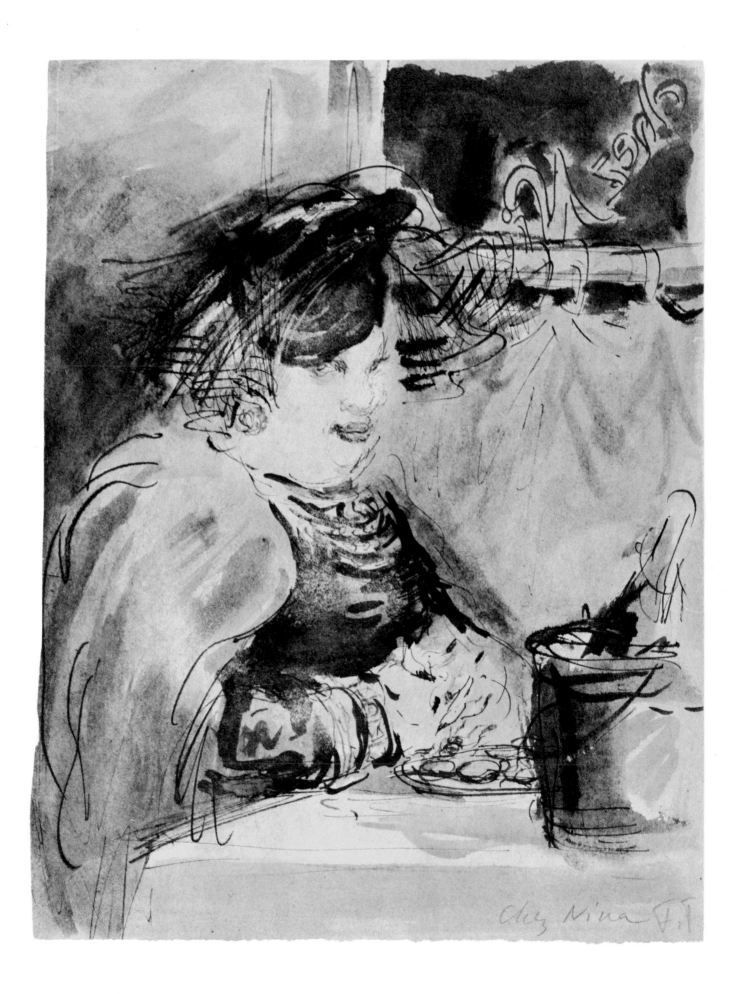

Chez Nina 71

82. La banlieue

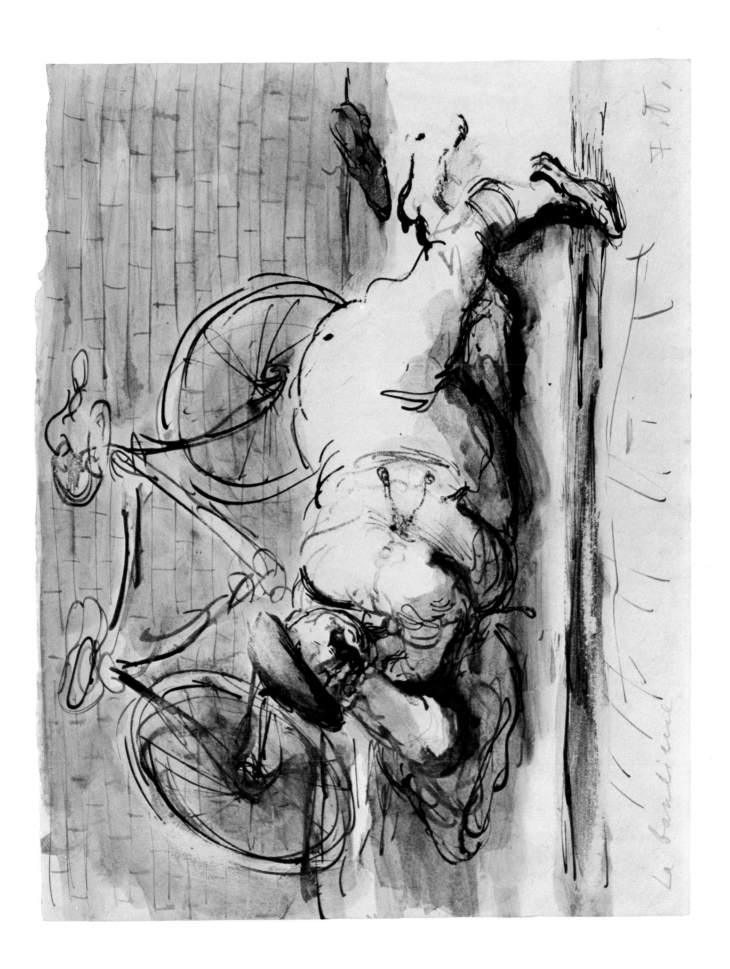

83. Café de la Paix

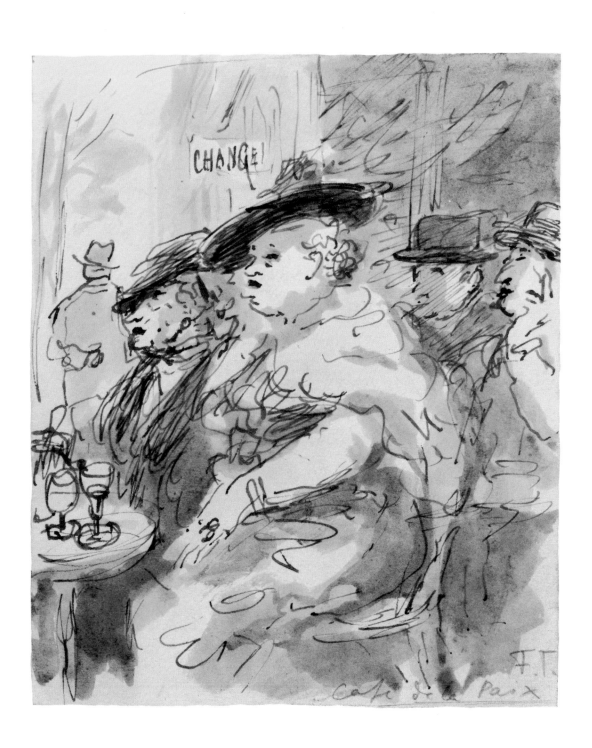

CHANGE

Café de la Paix

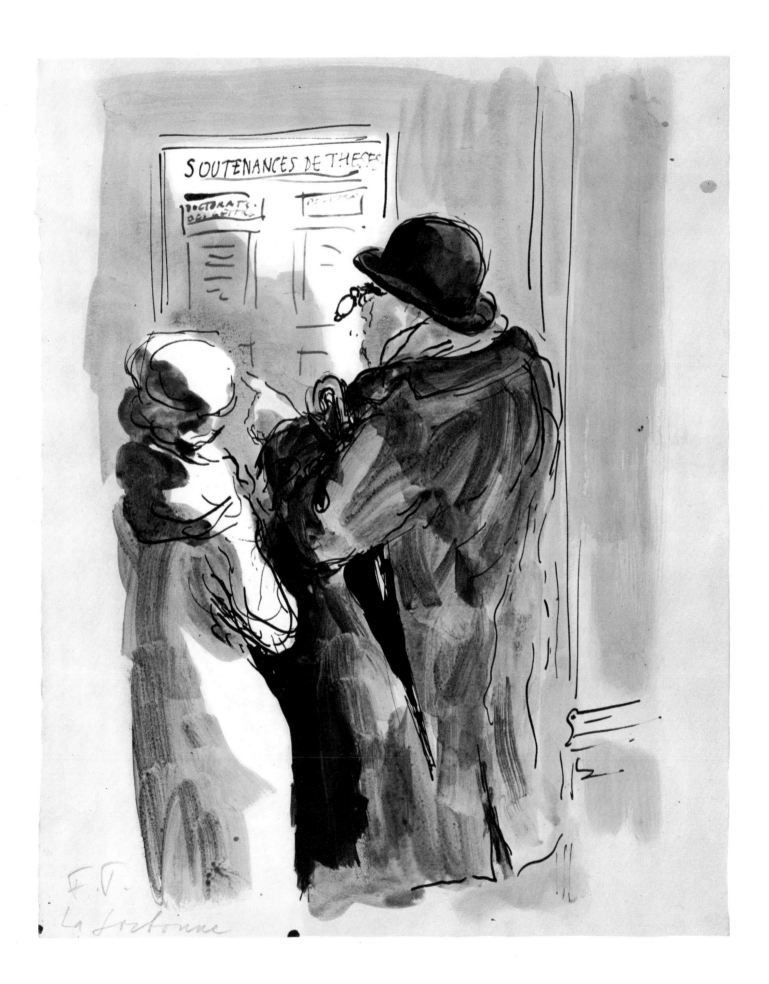

85. Un Fort des Halles

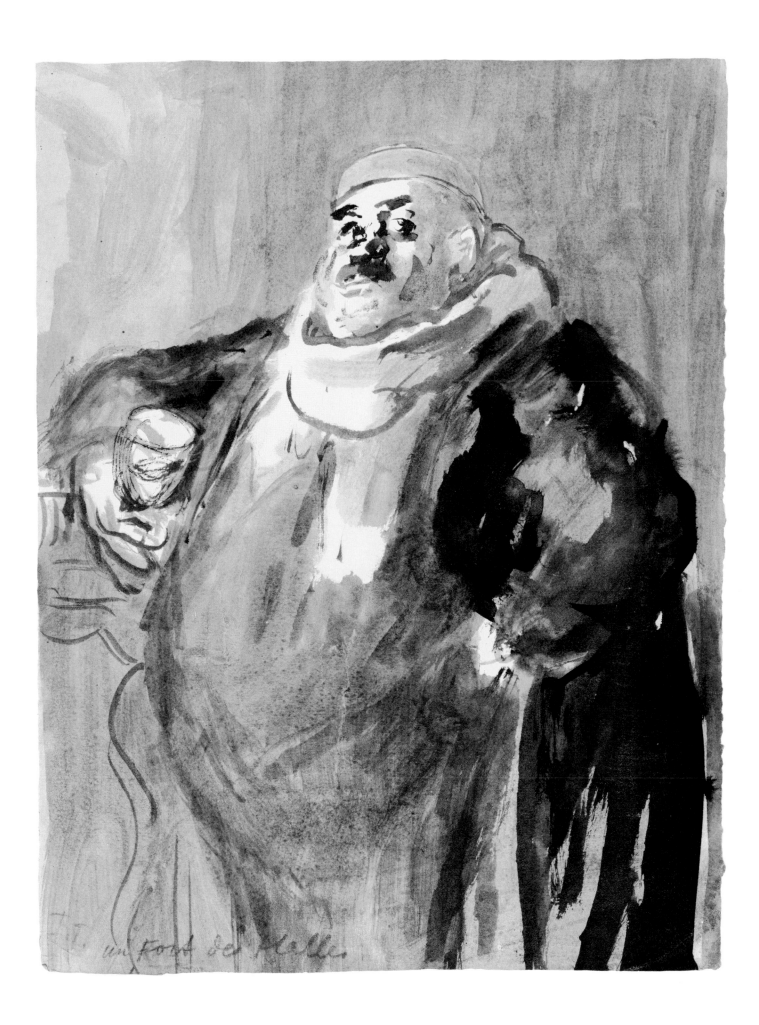

86. Concert Mayol (2)

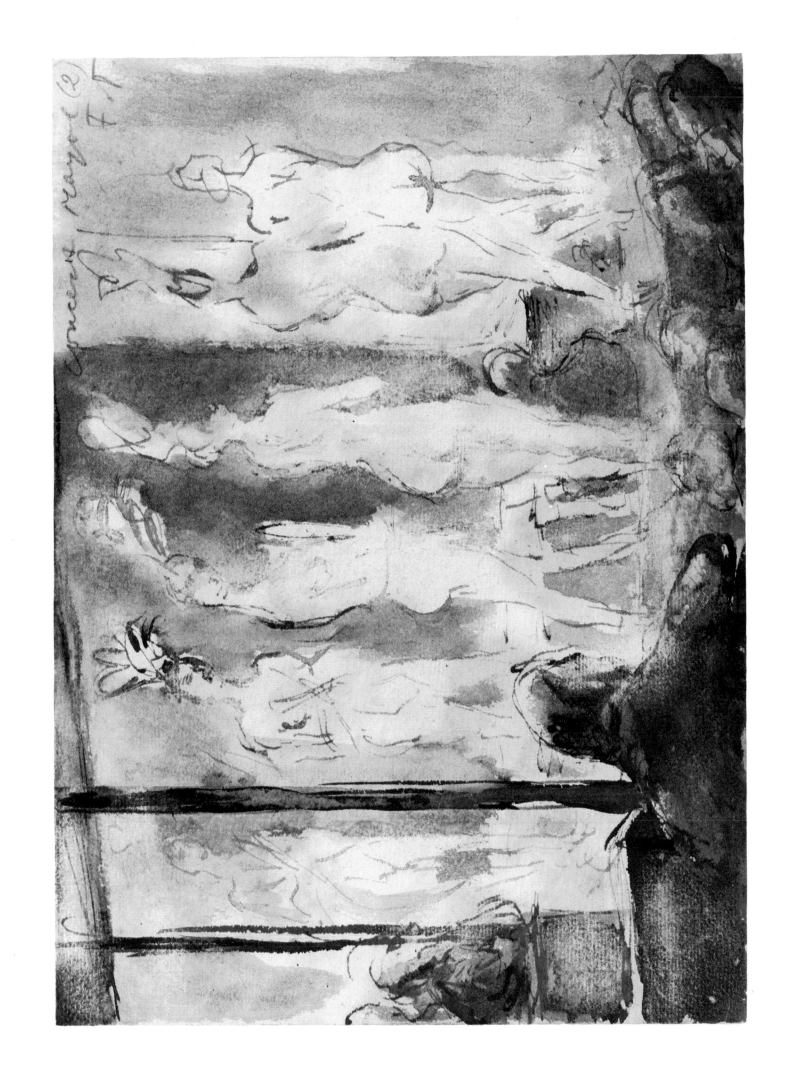

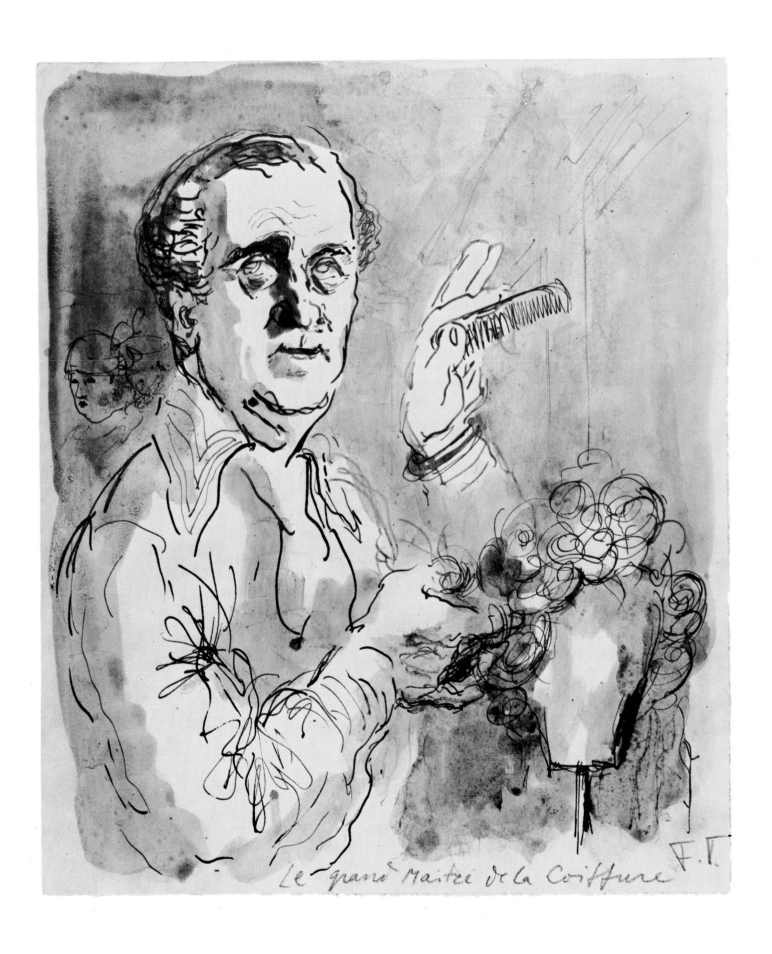

Le grand Maitre de la Coiffure

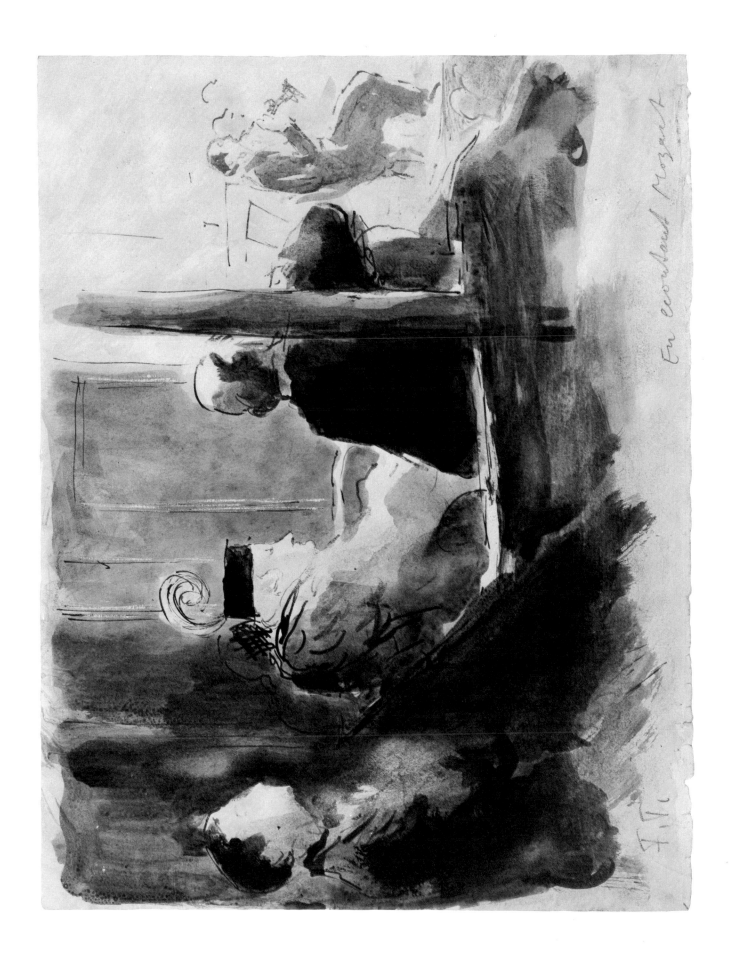

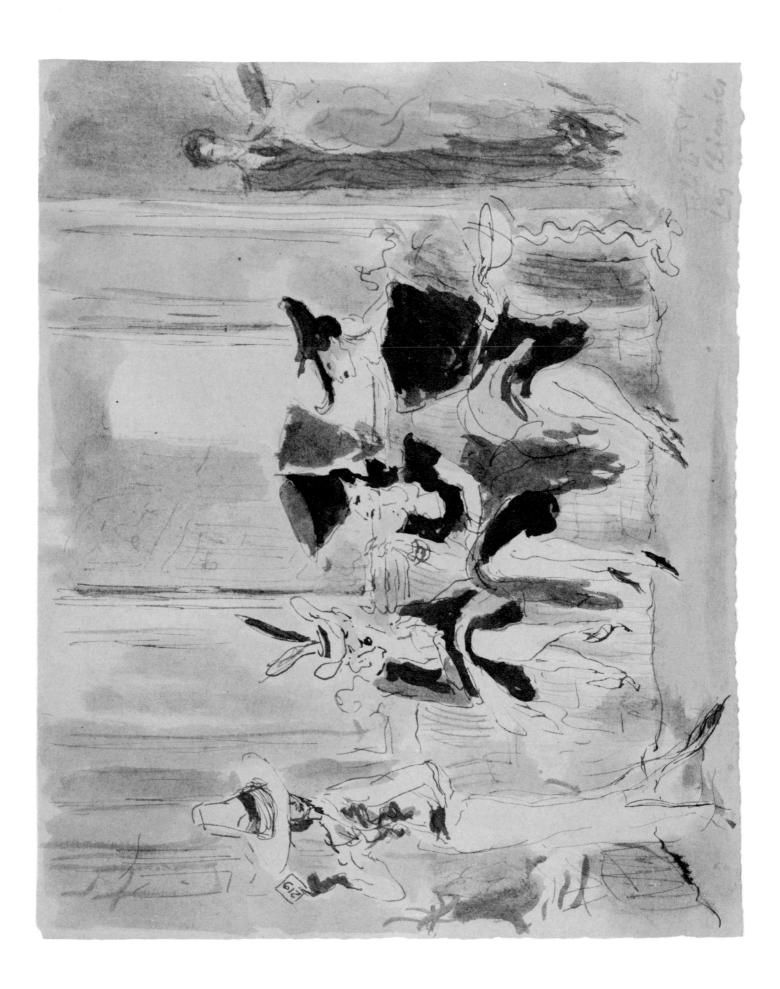

90. Au Faubourg St. Antoine

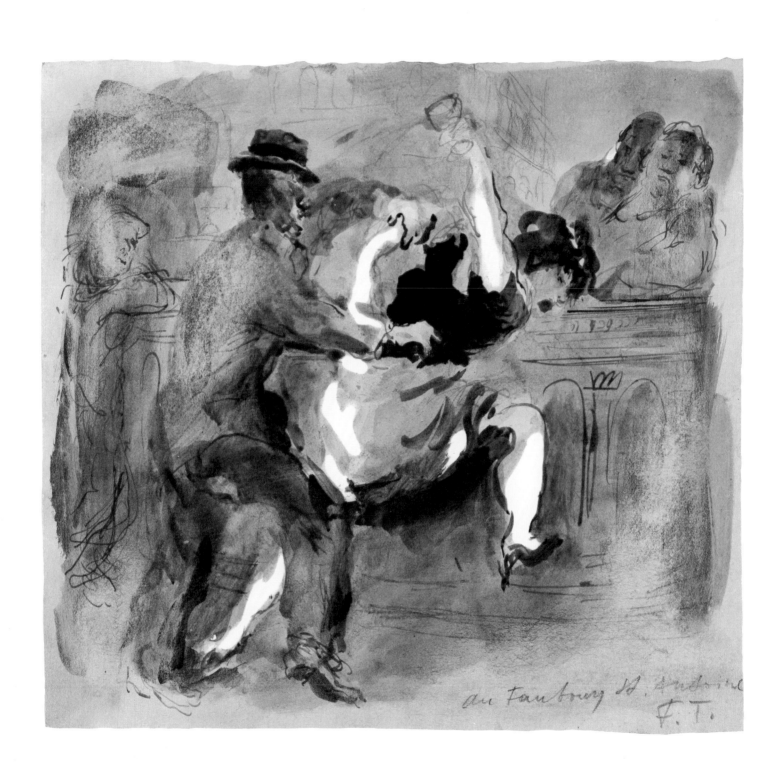

au Faubourg St. Antoine
F. T.

91. Quartier St. Paul

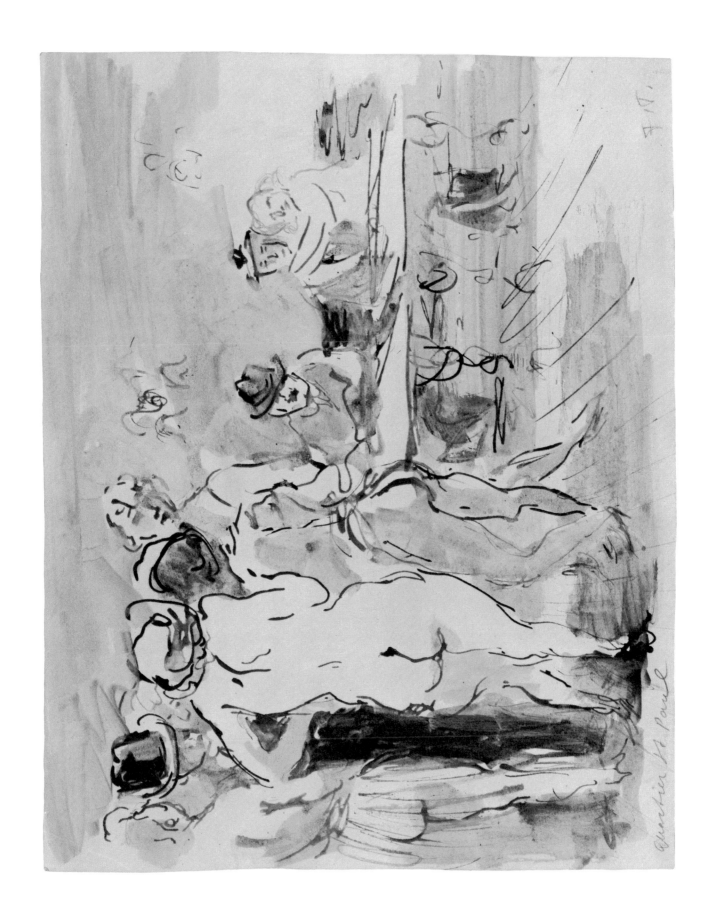

92. Chez le peintre en vogue

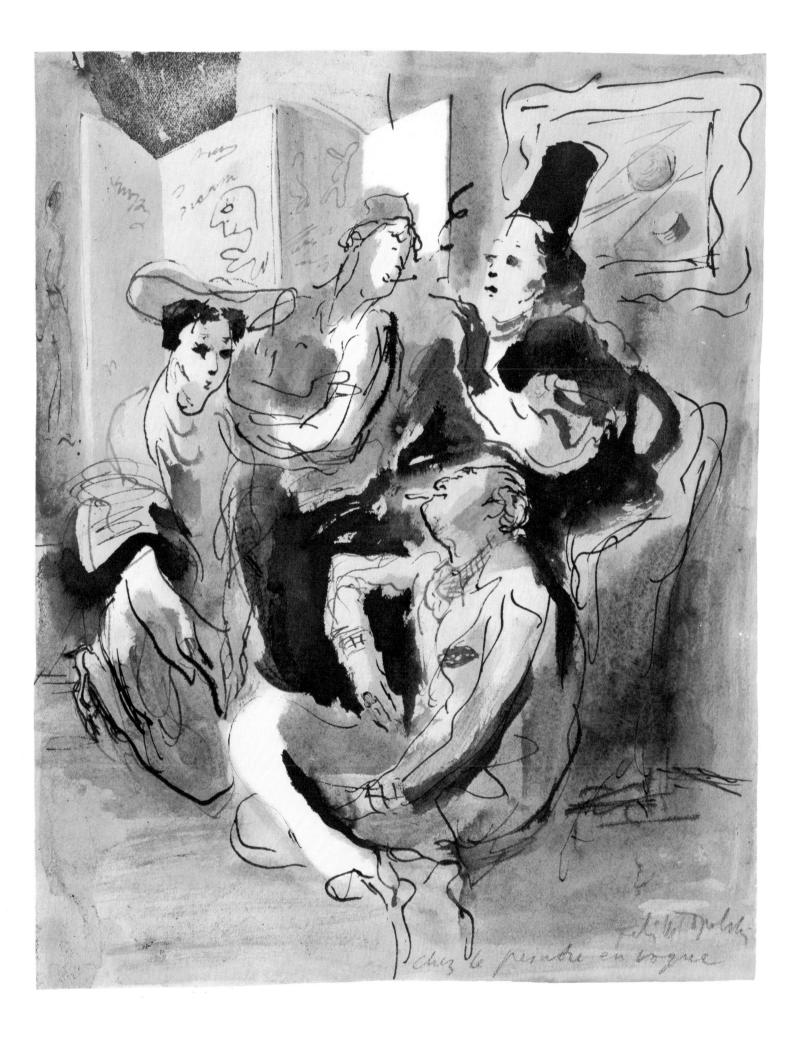

chez le peintre en vogue

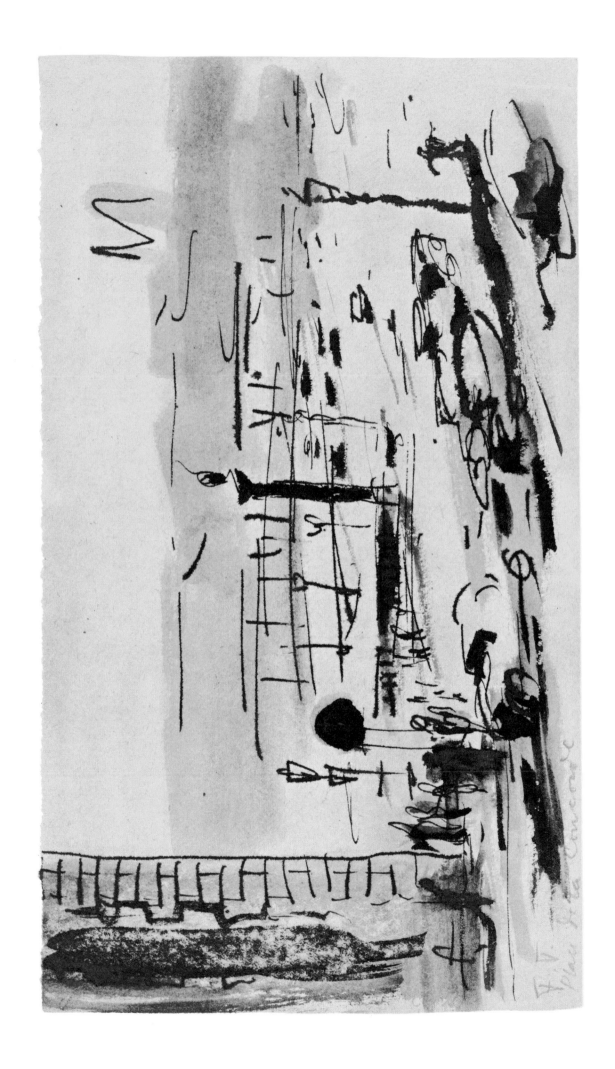

94. *Parois de Notre Dame – la nuit*

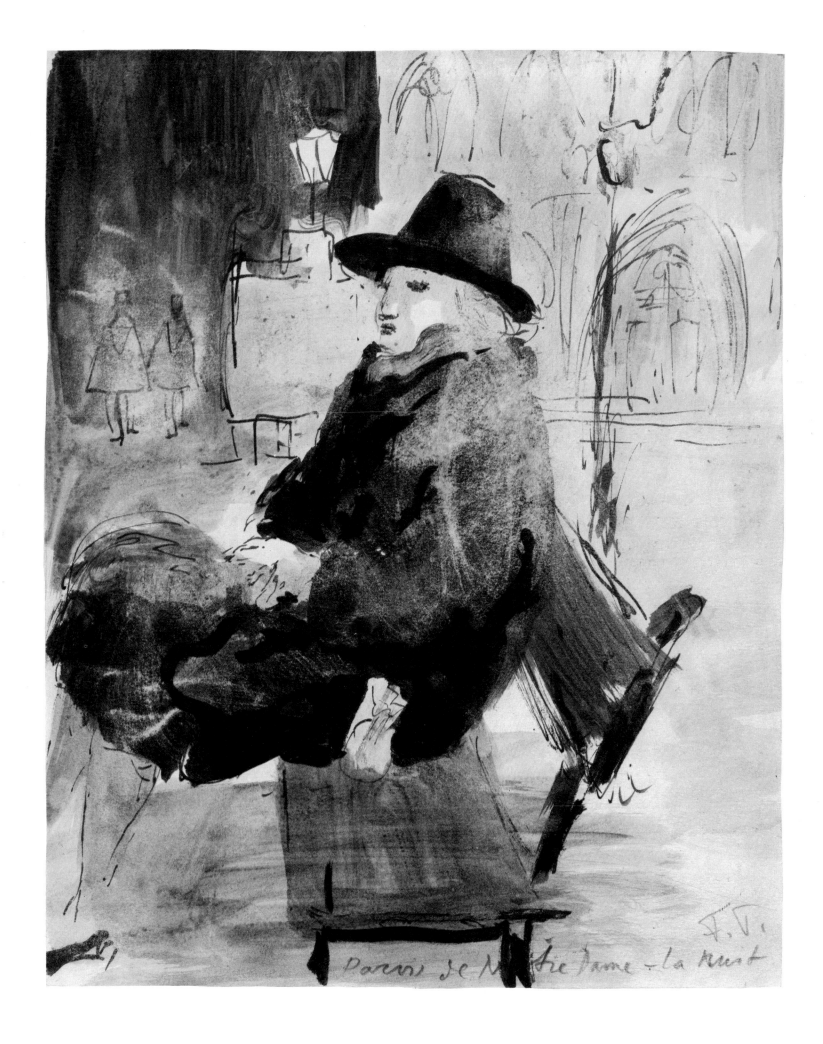

Parvis de Notre Dame - la nuit

95. *"Sheherezade"*

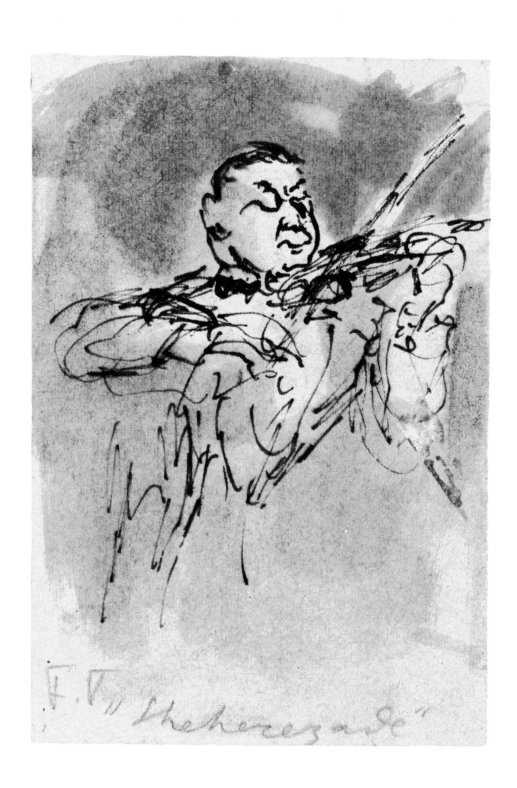

"Sheherezade"

96. Salle du Jeu de Paume

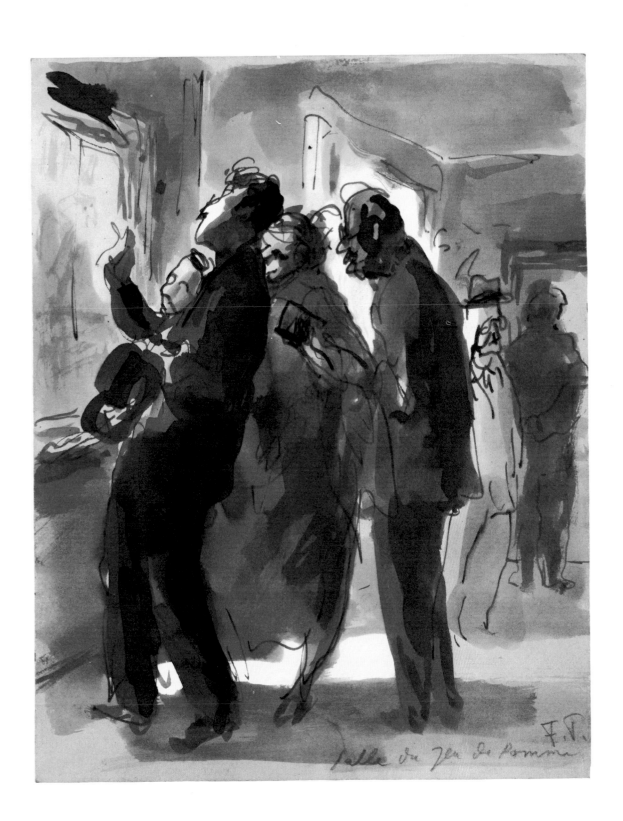

Salle du Jeu de Pomme